THE NEW VISION

FORTY YEARS OF PHOTOGRAPHY

AT THE INSTITUTE OF DESIGN

AN APERTURE BOOK

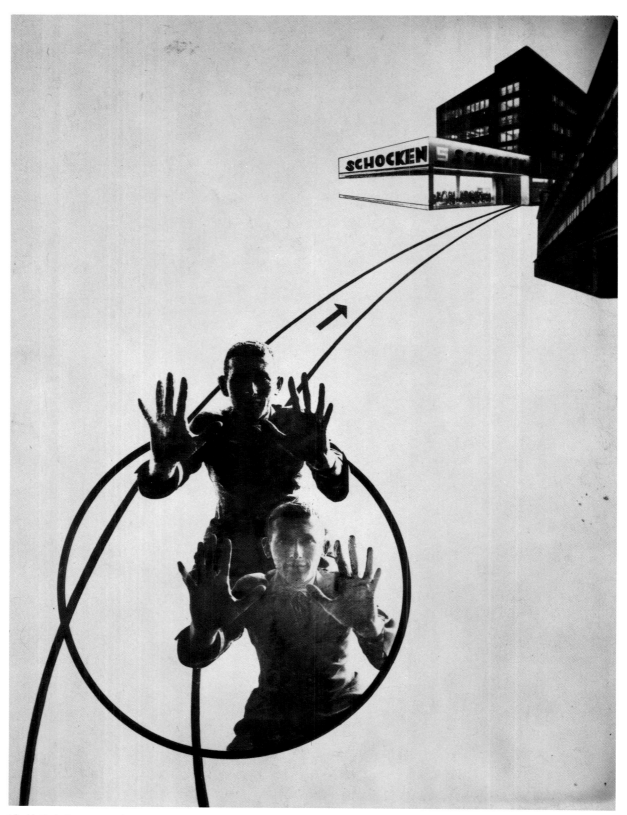

László Moholy-Nagy, *Schocken* (photoplastic), 1927–28

CONTENTS

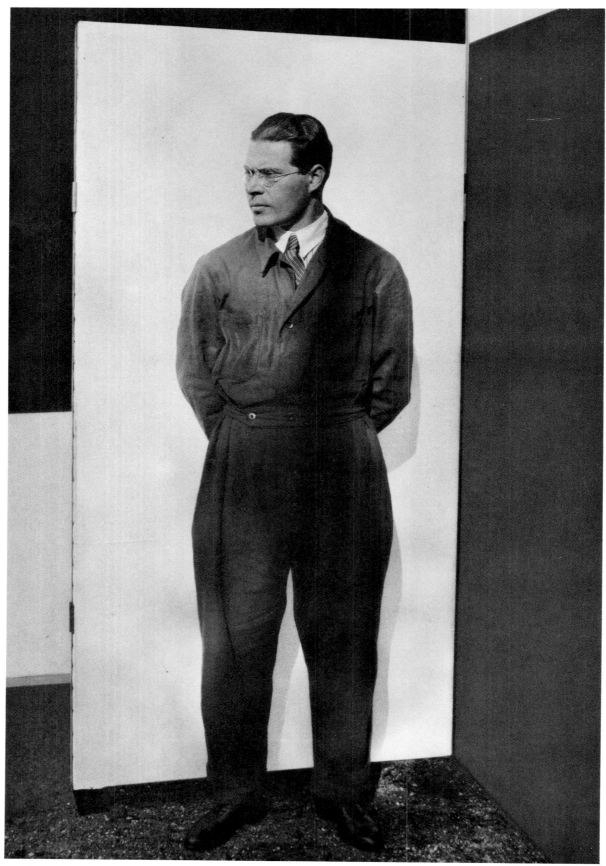

László Moholy-Nagy, Dessau, mid-1920s

CHICAGO'S INSTITUTE OF DESIGN, established by László Moholy-Nagy in 1937 as the New Bauhaus, is the seminal place for the education of the modern artist-photographer. The New Bauhaus's original goal was to produce "universal designers," and its course of study offered an eclectic mix of science, art, and social studies. Perhaps because this mixture included photography as a serious discipline for the first time in the environment of higher education, the medium flourished as it had at no other school in America. Over a period of more than forty years the photography program grew away from the general orientations of the school and its administrators and developed its own identity as the result of the charisma of its most important teachers—Harry Callahan and Aaron Siskind. In addition to these two great mentors many of the most important contemporary photographers—Arthur Siegel, Art Sinsabaugh, Ray K. Metzker, Nathan Lerner, Garry Winogrand, William G. Larson, Kenneth Josephson, and Thomas Barrow—have been connected with the I.D., and hardly a university exists in the United States that does not have a photography teacher who studied there or was a student of one of its students. The number of photographers who can trace their roots to the I.D. is a fitting tribute to a remarkable program.

Through the efforts of Siegel, Siskind, and Callahan the program has acquired and held its reputation as a motivating force in photography, but its origins are clearly in the organization and ideas of its founder, Moholy-Nagy.

By his own report, Moholy had little formal education in art. Born in 1895 in Hungary, he made his first creative efforts in poetry, which he first published at the age of thirteen. In the army in World War I, he was wounded on the Italian front and during his months of convalescence he turned idly to sketching, a pastime he so much enjoyed that when he returned to Budapest to study law after the war, he eventually adandoned his studies to pursue an interest in art. By 1920 he had moved to the exciting mecca of Berlin, where he came into contact with the major art movements of the day—the Russian Constructivists El Lissitzky, Ilya Ehrenburg, and Naum Gabo; the Suprematists Kazimir Malevich and Aleksandr Rodchenko; and the Neoplasticist Dutch painter Theo van Doesburg. Under the influence of these technology-oriented forms of art, Moholy began to experiment with a wide range of media, including photograms—cameraless photographs—on which he collaborated with his first wife, Lucia Moholy. His paintings, photograms, and writings attracted the notice of Walter Gropius, who invited him to Weimar in 1923 to join the Bauhaus, Europe's avant-garde design and architecture school. His feelings about the function of art in society accorded well with the commitment of the Bauhaus to social reform through good design:

> Art is the most complex, vitalizing, and civilizing of human actions. Thus it is a biological
> necessity. . . . Our culture is full of those illiterates who cannot read or write and

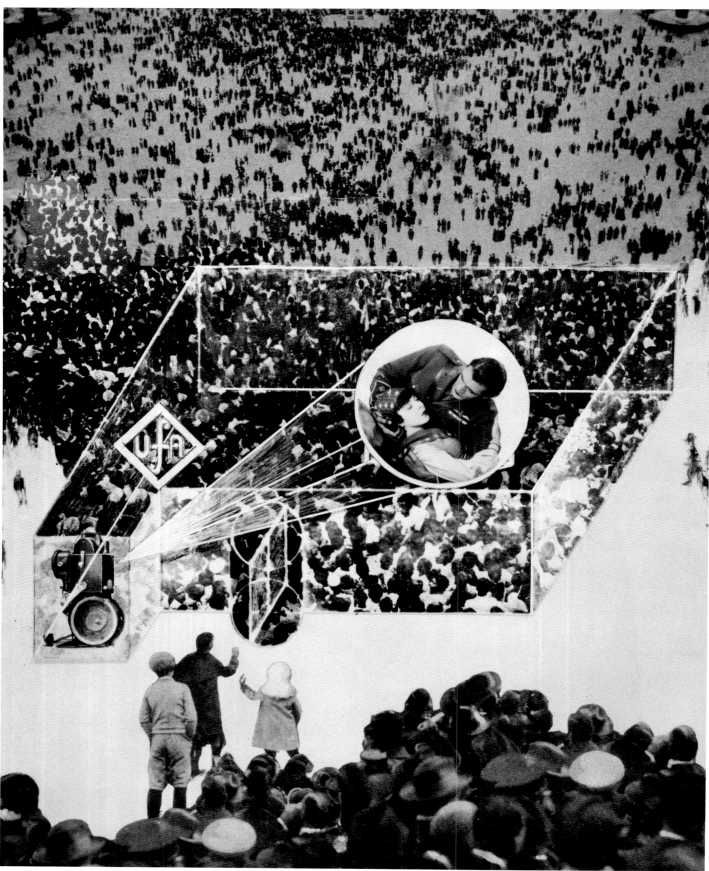

Collage by László Moholy-Nagy, 1925

others—the illiterates of the emotional life, who live without ever attempting to translate their emotions into meaningful expression. To live without this means emotional starvation just as missing food means starvation of the body.

In Moholy's preliminary design course at the Bauhaus, the student of art and design worked much like the student of science, observing and experimenting with materials and methods until he produced a new solution to a problem. He used the traditional tools of his trade, but he also worked with the camera, examining the textures of wood through microphotography, and with photograms, exploring infinitesimal gradations of light and shadow. Moholy's own photography of this period includes some of his best-known "straight" photographs, which succeed by combining architectural forms with a counterpoint of people in abstract compositions.

After the Bauhaus collapsed under pressure from Fascists, Moholy spent several years in England, before arriving in the United States in 1936 with his second wife Sibyl and their children to start a new school on the Bauhaus model. Curious American reporters described "a human dynamo, big-headed, big-shouldered. . . . His face is broad and smooth, his nose is long and sharp, his mouth is wide and always smiling. . . . He laughs easily, uses all his muscles when he talks, hates to talk about himself, but will talk for hours on his theories of the school":

> Our policy is not to dominate the student [but] to provide him with the opportunity to become conscious of the world and himself through exercises which simultaneously train the intellectual and emotional spheres. This policy is a powerful incentive to the teacher, too, as it lessens the dangers of clinging to traditional fixations or academic servitudes.

In his ideas and in the program he designed for his New Bauhaus, photography always held an important place:

> It is unprecedented that such a "mechanical" thing as photography . . . should have acquired in barely a century of evolution the power to become one of the primary visual forces in our life. Painting, sculpture, architecture and especially the advertising arts [are] nourished by the visual food which the new photography provides. There is the incisive sharpness of camera portraits pitted with pores and furrowed by lines, the airview of a ship at sea moving through waves that seem frozen in light. . . .

László Moholy-Nagy surrounded by his students at the School of Design, Chicago, 1945 (photo: Frank Sokolik)

9

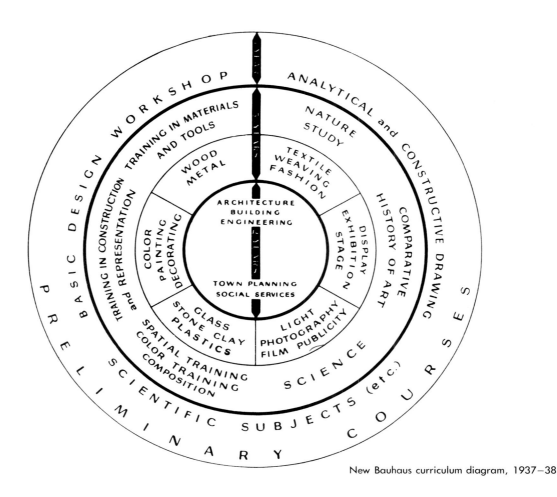

The diagram contains the following labels, reading from the outer rings inward:

BASIC DESIGN WORKSHOP · ANALYTICAL and CONSTRUCTIVE DRAWING

TRAINING IN MATERIALS AND TOOLS · NATURE STUDY

TRAINING IN CONSTRUCTION and REPRESENTATION · COMPARATIVE HISTORY OF ART

WOOD METAL · TEXTILE WEAVING FASHION

COLOR PAINTING DECORATING · DISPLAY EXHIBITION STAGE

ARCHITECTURE BUILDING ENGINEERING

TOWN PLANNING SOCIAL SERVICES

GLASS STONE CLAY PLASTICS · LIGHT PHOTOGRAPHY FILM PUBLICITY

SPATIAL TRAINING COLOR TRAINING COMPOSITION · SCIENCE

PRELIMINARY SCIENTIFIC SUBJECTS (etc.) COURSES

New Bauhaus curriculum diagram, 1937–38

In his New Bauhaus, Moholy promoted exploration of technique: photomontage, photoplastic, photograms, color photography, any innovation a student could devise in the Light Workshop. Visitors to the school, first housed in the old Marshall Field mansion, and later in an office building with a Walgreen drugstore on the ground floor (Moholy joked that the building had originally been used as a barn), described a handsome interior of labs and workshops with soft gray walls and streamlined furniture. In 1946, just before he died of leukemia that same year, Moholy sat talking with a reporter in his office, under a painting called *Nucleus*.

> I went to Hollywood and they showed me beautiful girls. But when they opened their mouths I saw they were all drugstore girls. They should be beautiful of spirit as well. No, I don't like that connotation of the word *beauty*. Utility and emotion and satisfaction, those are more important words. Those are the things design should give. For thirty years I have acted pretty much on intuition. And now I know I was pretty much right. The great educators foresaw our dilemma. People think I am crazy. But then they see I have trousers on, and a necktie and they say, "No, he's normal." When I was young I was always very annoyed. But now I realize how important it is to be always patient.

The utopian dream Moholy worked for never became reality, despite his dedication and energy, but his new vision was a powerful legacy, especially for photographers, who could see their "mechanical" art as the means for objective vision, optical truth, and personal enlightenment.

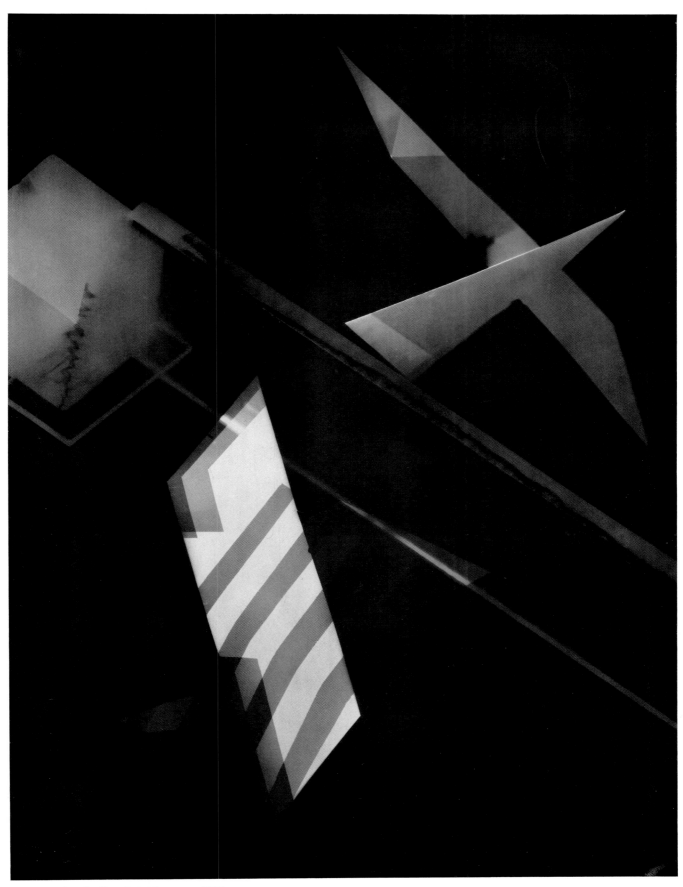

Photogram by László Moholy-Nagy, ca. 1925

WITHIN THE SMALL and, until recently, sealed world of photography the Institute of Design has been identified with that medium more than other visual arts schools are identified with any single medium in which their graduates work. This emphasis is the result of, but explains very little about, the intellectual context in which the school functions, a context that has proved a stronger influence on photography (and on modern art) than any of its teachers or students or even the institute itself.

The vision of László Moholy-Nagy is the most proximate source of the I.D.'s unique qualities. During his years at the Bauhaus in Germany (1923–28) he had developed a particular and peculiar version of Modernism. In 1937, after several years in England, he took that version to Chicago. He did not take it to New York, to Peggy Guggenheim's Art for this Century Gallery, as the Surrealists later did, or to the academic sponsorship in the northeast, as Josef Albers and Walter Gropius did. Moholy went to Chicago, a determinedly American and commercial city, invited by a consortium of businessmen and the American Association of Art and Industries. He called his school the "New Bauhaus."

The German Bauhaus was not a cohesive movement, but the focus for many artistic and social movements in Europe from 1919 until 1933, when Nazism forced the school to close. In the original Bauhaus manifesto of 1919, Gropius called for the reunification of the arts under architecture, taking his model from the social, economic, technological, and artistic unity that produced the great cathedrals. It was not architecture, however, that created that unity, but the common belief that man's mission on earth was to praise God. Religion, and the subordination of individual achievement to an extrapersonal, supernatural goal, created the synthesis that ordered the priorities of medieval Europe and placed art in a prominent role in society. Gropius posited a new unification in which the "total building" would be the collective expression of revolutionary values—artistic, moral, and social. The new architecture would be the crystalline cathedral of social justice and socialist democracy born out of the final destruction of the old order in World War I.

Above, from top, Joseph Albers's design for stencil alphabet, 1926; Insignia of the Staatliche Bauhaus, after a design by Oskar Schlemmer, 1922; Insignia of the New Bauhaus, Chicago, 1937

Left, László Moholy-Nagy, 1940; above, Johannes Itten, instructor of Preliminary Course, Bauhaus, Weimar, 1921

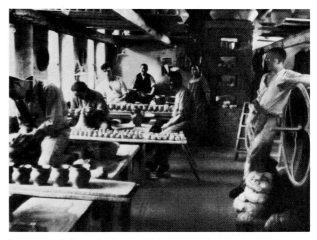

IDEE UND AUFBAU
DES STAATLICHEN BAUHAUSES
WEIMAR
VON WALTER GROPIUS

BAUHAUSVERLAG G.M.B.H MÜNCHEN

Left, Walter Gropius, Bauhaus founder, Weimar, 1919; *right*, Walter Gropius's title page for *Bauhaus 1919–1923*

Pottery workshop, Bauhaus, Weimar, c. 1923

The essential vision of the Bauhaus was utopian. For the generation that matured during World War I, the conflict possessed a metaphysical dimension. It put a complete end to the aspirations of the past. At least twenty million Europeans died for principles that could no longer be believed. All the "big words" were lost. Yet, although Europe lay in ruins, many survivors of the war were optimistic about the future. The past was dead and the future could be born. A new and apocalyptic eschatology began to develop, and the Bauhaus was at the center of the movement. The violent distortions of society caused by the conflict between old ideas and new technology in the nineteenth century would be ended. The world would be made over, made new, made perfect. As with Marxism the achievement of this absolute goal allowed for no further development. It implied a new posthistorical age—the Modern. The Bauhaus represented

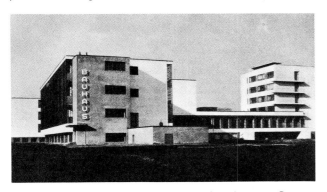

The Bauhaus building, designed by Walter Gropius, Dessau, 1925–26

a promised new world and a new education for its inhabitants. Moreover, just as the cathedral was not only the product of societal unity but also a didactic tool for creating unity, so *Bau* would, in some strange Skinnerian sense, modify mankind and create a new order.

In this view, the technological achievements since the industrial revolution (including photography), and the democratization that accompanied those achievements, had eliminated art's traditional patronage and removed the artist

from society. This separation allowed the development of the concept of individual genius as the sole requisite of art. To create the new order, genius, a perniciously undemocratic concept, had to be subordinated to societal goals. Yet the best art in Germany at the time was linked strongly to genius. Gropius hired the best artists as instructors but hoped that the teachings of these "form" masters would combine with training from the shopmasters to produce a new generation of artist-craftsmen who would be the ideal teachers.

There was no room for genius, but Johannes Itten, the first master of the Foundation Course, believed only in genius. At first Expressionism dominated the Bauhaus. While the masters could accept the stated goals intellectually, they could not avoid being and teaching what they were. In a social sense, Expressionism was retrograde: it liberated the individual but not his fellows. It was seen by some as irrelevant to mass society, yet it was Itten who gave the Bauhaus its most distinctive heurism: that solutions to visual problems grow out of direct experimentation with materials. In 1923 Moholy took over the advanced Foundation Course of the Bauhaus. He introduced a more clearly formed idea of the new unity than any other teacher except perhaps Gropius. Moholy's art grew out of Constructivism, the revolutionary art of Russia at the turn of the century. He recognized the conflict between the cultivation of artistic genius and social responsibility. Partly as a result of Moholy's influence, "art and technology—a new union" became the motto of the Bauhaus when it moved from Weimar to Dessau in 1925.

Moholy saw the revolution in the arts as inseparable from the social revolution. When society called on art to contribute, the artist had to lead the world to a new consciousness. To overcome the conflict between the responsibilities of genius to itself and genius to society, Moholy integrated the notions of Itten and those of Gropius into his own view of total education.

To teach art (read *genius*) is impossible and socially irresponsible. Art must be a private matter beyond schools,

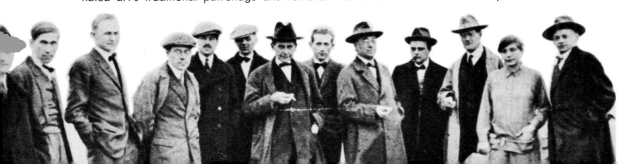

Faculty of the Dessau Bauhaus, 1926

beyond collective responsibility, an antisocial act of brilliance. An educator could, however, teach visual and formal elements and the methods of solving visual problems. He could create a cadre of "designers." Some of them might also possess genius, and their work could be classified as art. These designers would give form to building, industrial production, and mass communication through their control of form, thereby literally remaking the world. Instructed by design, society might even come to understand nonobjective painting. If immersion in art and its past was the rule of the academy—students at easels copy the masters—then immersion in materials would be the new regime. The new art could not spring from the decadent past: it had to be built out of the raw materials of the present machine age.

For Moholy the new artist had to emulate the scientist in his laboratory. Direct experimentation with the stuff of his art would be his method. Discoveries would lead to hypotheses about perceptual phenomena and the basis of communication that could be tested for their predictive validity. These discoveries would eventually give rise to a theory of form that would integrate art and science and revolutionize art, just as relativity had revolutionized physics. Modern science required a leap of faith, an absolute belief in the power of mathematics to describe and explain reality. Moholy's formalist synthesis held that form had its own syntax (a "language of vision" in Gyorgy Kepes's version), which is capable of revealing its meaning—both internal and external—in its own terms. Since the meaning of form was as yet unknown, each individual was free to interpret it for himself. On this level, art, architecture, advertising, and design were equal. In each activity the "designer" would give form to unspecific facts, metaphors, and meanings through his medium's unique vocabulary and transmit the results to a universal audience.

The "as yet wholly unknown morphosis," as Moholy called it, could not be predicted. Its achievement formed its own goal as it unfolded, though the nature of that goal remained obscure. Failure to predict a result did not, however, mean failure to specify a means of finding it. Objective means of determining the effectiveness of a visual work of art needed to be found. This search required first a wholehearted abandonment of all preconception and all conscious intention. Each artist was to become totally naïve, responding to art and to nonart with equanimity, learning from all things, particularly from things generated by present, not past, technology.

This attitude functioned well in an education based on craft. Craft was the manipulation of media. Experimentation could reveal new forms and new ways of seeing. Moholy believed that even the most evocative image created its effect through scientifically describable and precise means and that discovery of those means was near at hand. In the light of this new knowledge, those who rejected formal sufficiency would be seen as nothing more than posturing alchemists wedded to elitist politics, outmoded technology, and unjustifiable conceit. While the New Vision proceeded from a selective antipathy, both aesthetic and social, for art antedating nonobjective painting and contemporary Expressionist painting, it embraced nonart—the vernacular image. More could obviously be learned from accidental images than from conscious ones, since the phenomena that made an image effective were independent of artistic intent. If genius was the basis of art, then most of photography was not art because it was not the product of genius. After Freud, neurosis and obsession became the modern analogues of personal truth; in the realm of vernacular imagery, the simplest interpretation is that the image maker is unconscious of his motives and/or effect. Applied to teaching this interpretation creates an interesting paradox. If the assignment calls for formal or process manipulation, then the result must be evaluated in terms of the quality of its meaning since the form is constant. Ironically, formalism is distinguished not by concentration on form, but by concentration on metaphor.

In this system the student would be free from art that was stifled and stifling, free to conceive art that was original. Each would re-create the world by re-creating not the wheel but the rotary friction reducer, not the chair but the body-support system, not art but something better than art and therefore greater as art. This complex of attitudes constituted a powerful methodology for probing the possibilities of newness, for leading the vanguard of the left in a hellbent pursuit of the final and absolute truth that would free man from his pride and his past, the realization of the posthistorical absolute in which art, society, and technology would be one.

Photography was central to this new synthesis for several reasons. The camera and its product are essentially democratic. The output of the camera is a multiple original easily produced in large quantities—therefore cheap and available to all. It is also the kind of image least affected by translation to halftone and small scale for replication by a

printing press. The camera is itself a machine and therefore objective, showing the artist how to see anew. It is democratic in its treatment of its users as well. Those who use it need not possess a talent for drawing or the ability to imagine a result. Anyone can rapidly be taught to make images with it. It is also important as a means for discovering the nature of painting. What the camera can do best obviously affects the idea of what painting can do best. If one of the unique qualities of the photographic image is its uncanny realism and the duplication of the actual appearance of things in incredible detail, then painting cannot compete with its exact means in the depiction of the world. In contrast to photography, painting addresses the pure expression of form and color beyond representation. The camera taught the painter what painting was not.

In 1924 Moholy summed up his attitudes in *Painting, Photography, Film* and specified the outline of the new camera vision. Later, in *Telehor* (1, no. 2, 1936), he codified those views:

The Eight Varieties of Photographic Vision

1. Abstract seeing by means of direct records of forms produced by light; the photogram which captures the most delicate gradations of light values, both chiaroscuro and colored.

2. Exact seeing by means of the normal fixation of the appearance of things: reportage.

3. Rapid seeing by means of the fixation of movement in the shortest possible time: snapshots.

4. Slow seeing by means of the fixation of movements spread over a period of time: e.g., the luminous tracks made by the headlights of motor cars passing along a road at night: prolonged time exposures.

5. Intensified seeing by means of: (a) micro-photography; (b) filter-photography, which, by variation of the chemical composition of the sensitized surface, permits photographic potentialities to be augmented in various ways—ranging from the revelation of far-distant landscapes veiled in haze or fog to exposures in complete darkness: infrared photography.

Above, Photogram by László Moholy-Nagy; *far right, top,* Mies van der Rohe at the Institute of Design, c. 1952 (photo: Harry Callahan); *bottom,* Metal chairs by Marcel Breuer, 1926

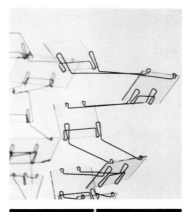

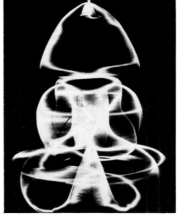

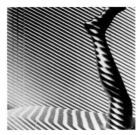

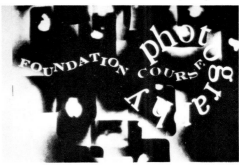

Above left, Wire and glass infinite column from three-dimensional Foundation Course, 1960s; *right,* Light modulator image by M. Griffis, 1970s; *below left,* Virtual volume image of spinning wire, c. 1940; *right,* cover of handmade book, *Foundation Course Photography,* designed by Bluhma Lew and Joseph D. Jachna, early 1960s

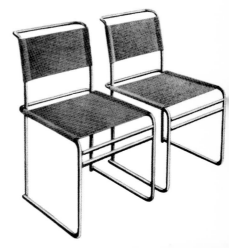

The School of Design incorporated not for profit embodies the principles and educational methods of the Bauhaus founded 1919 in Weimar by Dr. Walter Gropius, now chairman of Architecture at Harvard University. In the book "Bauhaus 1919-1928" published by The Museum of Modern Art, Director Alfred H. Barr, Jr., comments as follows:

"Why is the Bauhaus so important?
1. Because it courageously accepted the machine as an instrument worthy of the artist.
2. Because it faces the problem of good design for mass production.
3. Because it brought together on its faculty more artists of distinguished talent than has any other art school of our time.
4. Because it bridged the gap between the artist and the industrial system.
5. Because it broke down the hierarchy which had divided the 'fine' from the 'applied' arts.
6. Because it differentiated between what can be taught (technique) and what cannot (creative invention).
7. Because its building at Dessau was architecturally the most important structure of the 1920's.
8. Because after much trial and error it developed a new and modern kind of beauty.
9. And, finally, because its influence has spread throughout the world, and is especially strong today in England and the United States."

15

6. Penetrative seeing by means of X-rays: radiography.

7. Simultaneous seeing by means of transparent superimposition: the future process of automatic photomontage.

8. Distorted seeing: optical jokes that can be automatically produced by: (a) exposure through a lens fitted with prisms, and the device of reflecting mirrors; or (b) mechanical and chemical manipulation of the negative after exposure.

The photographer was to analyze each object for form and process only. Only content and intent distinguished art photography from advertising photography. In all cases the language of form could be read the same way. Artists and advertisers could be taught the same thing if that thing remained tied to image making and not image meaning. The effects of this theory of photography—variously called "optical formalism" and "camera vision"—have been far-reaching. It is formalism alone that allows us to put the vernacular image and the images of Man Ray, Irving Penn, Weegee, Harold E. Edgerton, and Lewis W. Hine on the same wall. The new artist tried to be as smart as the camera.

Above, Buick assembly line, 1951; Flappers listening to radio, 1929; *left,* Gestetner duplicating machine before redesigned by Raymond Loewy; *below,* Designers' vision of future transportation, 1946

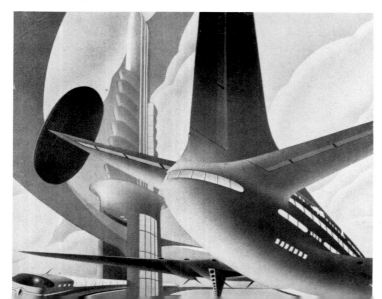

During the 1920s Europe had been the hub of frantic intellectual and artistic activity. Americans who wanted culture quickly left the United States for Paris or Berlin. They fled to a new world of ideas that had been facilitated by the dislocations of total war; they also fled from what F. Scott Fitzgerald saw as America's goal, "the pursuit of some vast, vulgar and meretricious beauty." For the United States the 1920s was a time of unplanned and unorganized economic boom and of the paired opposites of high private living and high public morals begotten of a war that, for America, was a triumph of military and economic power. The commercialism that would alternately be praised and ridiculed in the movies of the 1930s ruled the land. Through radio and the burgeoning publications business, advertising budgets jumped fivefold. The field of advertising was expanded in earnest, out in the open, hawking not only products, but also its own social utility as a means of bringing greater economic growth and prosperity to all. When the Depression hit full-stride in 1932 and 1933, politicians looked everywhere for scapegoats. Advertising received some of the blame for inflating expectations, and Congress passed legislation to curtail many of its excesses. The 1930s brought a brand of socialism to the United States, but not the sort

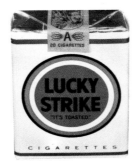

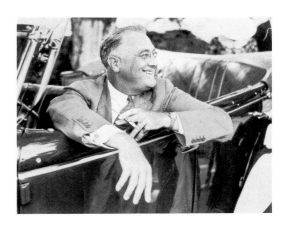

found in Europe, where centuries of class inequities caused a more drastic upheaval.

America has a long tradition of pragmatism. We have elevated the school of whatever works to the level of moral philosophy. Revolutionary socialism's inability to gather a substantial following in the United States has always mystified Marxists. The obvious reason for its failure—that we are a country of skeptics—seems too simple to be true. In the United States, egalitarianism has always been linked to capitalism. In the Depression we elected Franklin D. Roosevelt, the offspring of capitalist privilege, to offer the country a "New Deal." The object was not to create a new world order, but to regain the old one.

Reification had its part in all of this. What described the past could determine the future. Marketing principles dictated that once a market was created for a product, people would find a way to buy it. The new legal constraints on advertising necessitated more sophisticated strategies. The best way to capture and hold a market was to give a product and its advertising a distinctive "look." The industrialists of Chicago (not all of whom were venal) and the members of the American Association of Arts and Industries agreed on at least one thing: what was needed was a school that would produce distinctive images for marketing the products of American industry. (By 1941 this idea had penetrated so deeply into academia that it was advocated by Harvard Business School's Neil Borman.) In America, design is a function of marketing, not of artistic and social revolution.

In America in the thirties Moholy saw no culture but pop culture and backward regionalism. International culture had a colony in New York, but in the rest of the country it was little more than an occasional houseguest and an excuse for local pretentiousness. Still, Moholy was glad to accept the offer to head a school of design in Chicago patterned on the Bauhaus. His wife, Sibyl, privately doubted its potential for success, but Moholy, with his incredible optimism, jumped into the middle of a contradictory situation with no less grand an ambition than to seize the American industrial machine for his own artistic and social purposes. If culture did not exist and money was the only object, then so much the better. If the students were naïve, they were perfect. No one stood in Moholy's way because few people had any idea of what he was doing, and those who did could be easily satisfied with the promise of material gain.

The students who came to Moholy aspired to the New Vision he preached on his recruiting tours across the country in

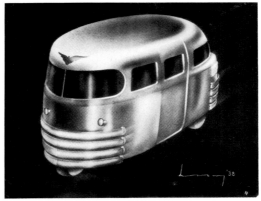

Above, Lucky Strike cigarette package, design by Raymond Loewy, 1942; Franklin Delano Roosevelt, 1937; Chrysler's taxi of the future, design by Raymond Loewy, 1938; *right,* Trylon and Perisphere Theme center, New York World's Fair, 1939–40; *below,* Chicago, 1935

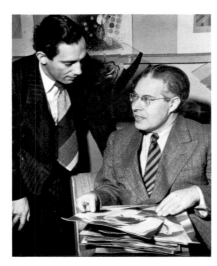

Above, 1905 South Prairie Avenue, Chicago, home of the New Bauhaus, 1937–38; above right, Chicago's mayor, Richard J. Daley, 1940s (photo: Arthur Siegel); right, Arthur Siegel and László Moholy-Nagy, Institute of Design, 1946

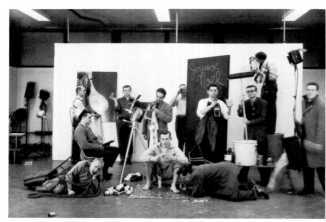

Above, "Joyeux Noel," Institute of Design Christmas card, 1957; left, top, 247 East Ontario Street, Chicago, second-story home of School of Design, 1939–45; left, bottom, 1009 North State Street, Chicago, Institute of Design's top-floor headquarters, 1945–46; below, Aaron Siskind, c. 1954 (photo: Arthur Siegel)

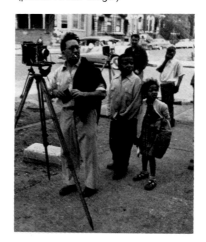

1937 but they were also Americans. They had absorbed an attitude toward technology different from that of their European Bauhaus counterparts, whose most recent experience of technology in the early twenties had been tanks, machine guns, and mustard gas. America was the land of Tom Swift and his Electric Dirigible, Amazing Science Fiction, and visions of a benevolent future technology. In Europe industrial technology represented a radical break with centuries of tradition. America thought technology was fascinating and fun—the very stuff of American history and the basis of its greatest success stories: Eli Whitney, Samuel Colt, Alexander Graham Bell, Henry Ford, Robert Fulton, Thomas Alva Edison. People grew up with Erector Sets and automobiles. The love of gadgets was as central to the American culture as the love of ideas was to the European.

Moholy believed first in the unity of science, art, technology, and humanity, and he foresaw creation of a just, prosperous, and beautiful world, both made and made beautiful by design. But what Moholy was selling and what Chicago was buying were two very different products.

When he set out to remake the school on his principles, problems arose. Moholy could not teach all courses. He sent for Gyorgy Kepes from Europe to head the Light Workshop (photography), but Henry Holmes Smith, an American, had to begin the course, and, because Kepes spoke little English when he arrived, Smith remained the principal instructor for weeks, giving assignments and carrying them out along with the class. Alexander Archipenko came to teach sculpture but found the situation not to his liking. He considered the school too commercial, and Moholy wanted him to function within the overall program, not as an independent master artist with his own audience. The rest of the faculty did not totally fall in line with Moholy's concepts, either. Some resisted the social aspect; others resisted the art. American education was not built on the European model. The professor was not the sole dictator of methods and policy. The faculty had to be convinced. Moreover, the board of the school continually interfered in operations, demanding that the school turn out marketable products immediately. Unlike the students in the technical high schools of Europe, the New Bauhaus students were of all ages and persuasions and had little respect for authority, especially that of professors. The students dubbed Moholy "Mahogany," but reserved most of their irreverence for his absence. Outside his classes, and any time he went on the road to lecture, morale began to deteriorate.

18

The total education Moholy gave his first students in 1937 reaffirmed their faith in American ingenuity and love of gadgetry, but it also offered a few surprises: new ideas, social visions, and new ways of thinking in the world of art. Moholy's own vision abounded in contradictions, and the school grew out of conflicting views about its nature and mission. Moholy hoped that the success of the school's real product—graduates steeped in the New Vision—would resolve any tensions, but by April 1938, well before his theories had a chance to be properly tested, the school had closed its doors. The participants fell to mutual recriminations that ended up in court. When Moholy reopened his school in February 1939 with his own funds, "Bauhaus" was conspicuously absent from its new name, the School of Design, but the ideas of the Bauhaus, or, more properly, Moholy's notion of what the Bauhaus had tried to be, were there. (The school was again renamed—the Institute of Design—in 1944 to underscore its college level standing.) Its finances were precarious and remained so until Walter Paepcke of the Container Corporation of America adopted Moholy as a personal project and, along with his wife, Elizabeth, supported the school until it joined the Illinois Institute of Technology in 1949.

Moholy's ideology remained intact only briefly. As soon as he began to teach in the United States, pieces of his synthesis were carried off and incorporated pragmatically into different ways of organizing and rationalizing the activities of photographers, painters, and industrial designers. The school clung to his vision in a peculiar way. Reassembling its intellectual shape in the virtual volume that his vision describes through time is like trying to collect all the versions of a traditional song like "Barbara Allen." In terms of photography at the Institute of Design, the most lasting aspect of Moholy's vision was the maintenance of photography as a medium equal to painting or sculpture. Because photography at the I.D. developed outside the immediate influence of the stronger traditions of other art media, it had the opportunity to become important, but this independence also had its negative aspects.

The I.D. represents an accommodation of the demands of American pragmatism and the theories of European ideology. Implicit in Moholy's formalism was a revolutionary message. Every person could have the best, could count himself—through the insights of art combined with the mass-production capabilities of industrial technology—at least the equal of every other person in the ownership of quality and equally able to own it (if not freely, at least reasonably). The goods artists had produced for kings, designers would produce for all. Everybody could have everything, pretty much in equal measure. Unfortunately, within the modern grid, personal space was not only equal, but uniform. Only within constraints was the individual free. The new uniform walls of white could be adorned with a wide choice of posters or photographs, and the space could be filled with modern products and conveniences, but the walls remained the edge and limit of individuality; each cell had to fit into the grid. Nonconformity could not be tolerated beyond the limits of the unit space.

Few Americans would stand still for this, even for a moment. The failure of highrise urban renewal and the success of "Mediterranean" furniture and discount-store original paintings are clear testimony. If Moholy's ideas seem silly and depressing in the present, it is only because acceptance and implementation have revealed weaknesses. The alternatives are equally bad. Should teachers declare that photography is identical to painting? That some media can be used by artists and others cannot? That craft is not the base of art? That commercial success is immoral? That the unique original is the only true work of art? That the audience for art is drawn only from the rich and the institutions? That the artist's only responsibility is to himself? That technology is antiart? Such a philosophy of self-indulgence can exist only in the subsidized world of university art departments.

The teaching method worked so effectively that no teacher really challenged it. Harry Callahan, Aaron Siskind, Arthur Siegel, and such visitors as Wynn Bullock and Frederick Sommer plugged in their own content and personal symbolism whether sexual, Abstract Expressionist, Freudian, mystical, or Surrealist. They taught within the context of design but lived for the few students who might become artists. Through its various lives with various directors each aspect of the New Vision was elevated in turn, while others were, for a time, demoted. New teachers brought new content, but the school's underlying structure remained the same.

At one point in 1955, Jay Doblin, who was appointed director of the school over faculty objection, determined to rid the school of its Moholy fixation. He cleared out the faculty and files and decried the reactionary Beaux Arts influence he saw in Moholy's ideas. (From his point of view he was probably right. Moholy never gave up the notions of genius or of the supremacy of fine art.) Yet the ideas remained.

Doblin eventually contented himself with building a specialized design school on top of Moholy's Foundation Course. While Doblin had come entirely out of the marketing notion of design through the studio of Raymond Loewy, at the I.D. he found himself toying with the idea of art. An unsigned painting he had made even caught the eye of Sidney Janis. In addition, Doblin personally financed the first publication from the Institute of Design Press, *The Multiple Image,* a book of Harry Callahan's photographs. For Doblin, though, this was a dangerous detour, and in the end he reaffirmed his basic concept of design as an activity based primarily on economic and material needs. Moholy had considered social, economic, and aesthetic systems to be interchangeable. The I.D. could provide a framework for many different teachers and generations of students because it never had a truly unified content. The school did not so much make a statement about the nature of the world as it defined a methodology for finding the appropriate form in which to put a statement.

All in all, Moholy's great synthesis, his experiment in totality, is deeply flawed. It is naïve, reductivist, and ahistorical. The hoped-for language of vision was never found and, all the thrashing of semiotics notwithstanding, never will be. Perhaps all unifying notions are like Edward Steichen's catchall photography exhibition "Family of Man," which derived its collective strength from irrelevant similarities. Moholy's followers and protégés knew this, so none kept total faith; each adopted only the parts that would work for him. The Design Synthesis is only one part of Modernism. Every working artist and movement collated the same data with different results. The extension of art into mass media and new technology was not necessarily imperative. The Surrealists, for instance, certainly did not see their work as parallel to any sense of growing collectivism, and they doubted the sufficiency of abstraction. Their language was psychoanalytic, not mathematical, and their absolute subjective, not scientifically verifiable. In the 1930s and 1940s many of the legendary figures of modern art—both Surrealists and Constructivists—sat out Nazism and World War II in the United States. Within a European context their movements were intellectually incompatible. A joinder of nonobjective form with psychoanalytic meanings would, by its nature, be ideologically impure, but Barnett Newman, Franz Kline, Jackson Pollock, Robert Motherwell, and other Abstract Expressionist painters made it work. Both the power and the instability of this arrangement became clear to me in a recent conversation with Aaron Siskind, in which he replied to a question, "Yes, I am a formalist . . . but that's not all . . . unfortunately."

Another part of the modern in photography and art in general is represented by Alfred Stieglitz, the dominant force in American photography at the time of Moholy's arrival. Stieglitz and the photographers he encouraged and exhibited at his various galleries had a different rationalization for photography. Stieglitz enjoyed the reputation of a seer. His dedication to personal truth and spirit were exactly what Moholy found most repugnant in art. Moholy saw this vision as a decadent cult of artistic personality descendant from Baudelaire. In fact, Moholy singled out Stieglitz in *Painting, Photography, Film* as an example of the romantic *Kitschshaft* the New Vision would bring to an end.

Part of Moholy's problem with photography was that he really knew very little about it. He could not see that Stieglitz had outgrown his nineteenth-century Symbolist sources. The qualities Moholy attributed to photography were abstract aspects of the medium that he imagined to be immutable and independent of the user. Stieglitz, Moholy reasoned, could not be modern because he sought to impose his "truth" on the medium. Stieglitz had integrated painting, sculpture, and photography into the metastructure art, based on the idea of equivalence. Moholy integrated art, science, and technology into design, based on the universality and total sufficiency of form. Within that formalism all manner of thoughts could exist but each had to be grounded in external not internal absolutes.

At various times craft, vocational training, art, antiart, pure experimentation, Freudian analysis, history, communication, social responsibility, and technological exploration have dominated the school's way of thinking. All could fit easily into the original framework maintained by an unbroken line of continuity to the past through the overlappings of the various teachers. Each new teacher offered his contribution, and it was absorbed in turn. No course ever followed the same format two years in a row, but neither was it wholly different. Personal expression found a home as various teachers explained the "why" of formalism and gave students a personal goal for mastering the medium. The school incorporated the tradition of Stieglitz, as well as the traditions of Surrealism, Freud, and as many other ideas as came through the door. Throughout these different cycles, photography predominated at the I.D., evolving through successive versions of its original role. The centrality of photography was and is what makes the institution unique.

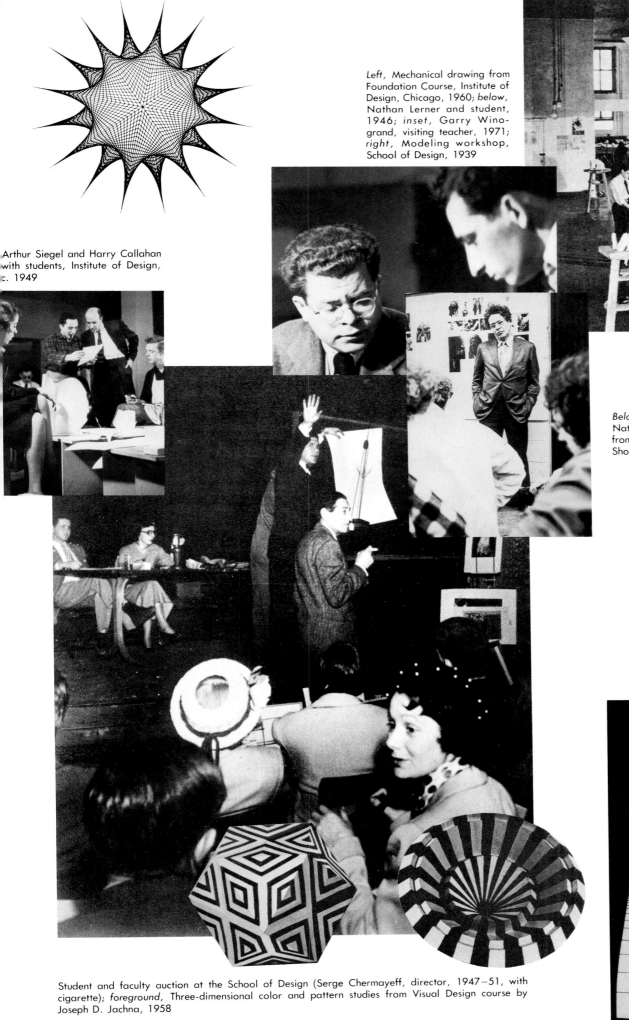

Arthur Siegel and Harry Callahan
with students, Institute of Design,
c. 1949

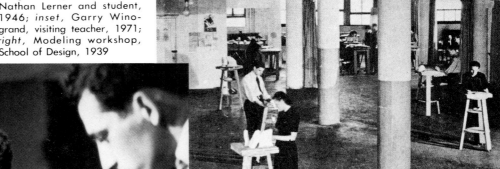

Left, Mechanical drawing from
Foundation Course, Institute of
Design, Chicago, 1960; *below*,
Nathan Lerner and student,
1946; *inset*, Garry Wino-
grand, visiting teacher, 1971;
right, Modeling workshop,
School of Design, 1939

Below, Bent plywood chair by
Nathan Lerner, 1940; Montage
from Visual Design course by T.
Shorer, c. 1950

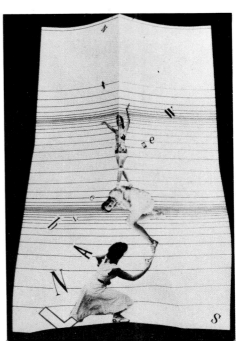

Student and faculty auction at the School of Design (Serge Chermayeff, director, 1947–51, with
cigarette); *foreground*, Three-dimensional color and pattern studies from Visual Design course by
Joseph D. Jachna, 1958

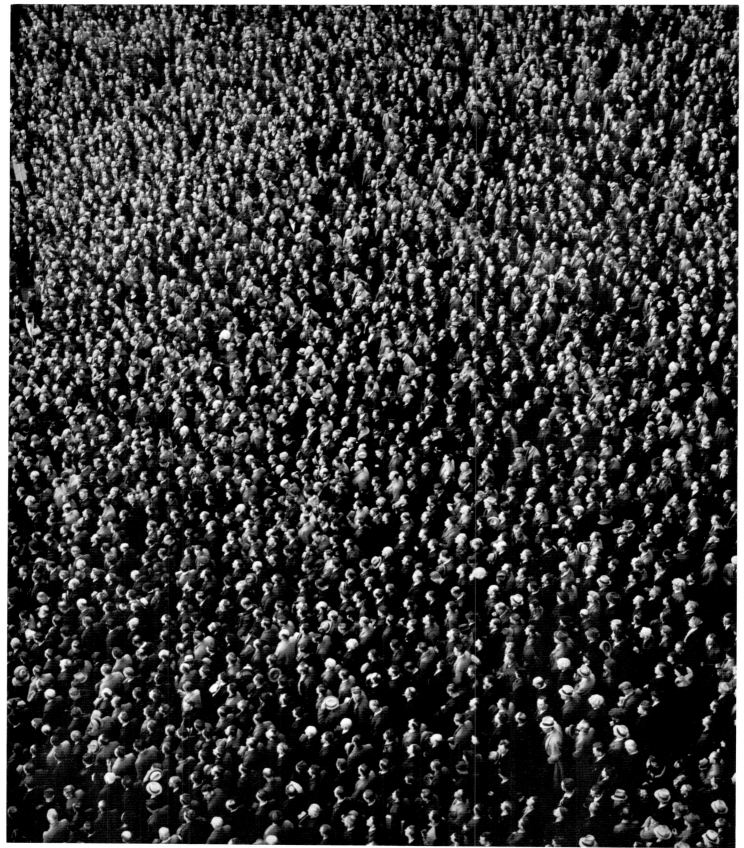

Arthur Siegel, *Right of Assembly*, 1939

LÁSZLÓ MOHOLY-NAGY'S NEW VISION of a universal designer—one who could work in any and all media—created a new validity in America for the teaching of photography in higher education. Moholy made photography an important part of the curriculum at the New Bauhaus from the start, and, as more technology demanded more specialization, a succession of creative photographer-teachers nourished the photography program, adding their personal visions to Moholy's foundation ideas. Two name changes (first to "School of Design" and then to "Institute of Design") did not interrupt this continuity. The program's strength, and its reputation, rested squarely on the student's attraction to particular mentors—Moholy, Arthur Siegel, Harry Callahan, Aaron Siskind, and, later, Garry Winogrand. The views of these teachers shed some light on the history of the photographic program at the I.D. and on the unique relationship between the ideas of faculty members and those of Moholy.

In 1937, when Moholy opened the New Bauhaus on Prairie Avenue in Chicago, the school first stated its aims:

—The New Bauhaus requires first of all, students of talent: the training is for creative designers for hand and machine-made products; also for exposition, stage, display, commercial arts, typography and photography; for sculptors, painters and architects (*New Bauhaus*, 1937, p. 3).

In Moholy's words the school's policy was

—not to dominate the student. To provide him with the opportunity to become conscious of the world, and himself through exercises which simultaneously train the intellectual and emotional spheres. This policy is a powerful incentive to the teacher, too, as it lessens the dangers of clinging to traditional fixations or academic servitudes ("New Education—Organic Approach," *Art and Industries*, March 1946, p. 67).

A prospectus was issued, derived for the most part from Bauhaus ideas. First-year students were to study sketching and photography, the properties of basic building material, and the physical and life sciences. (These courses later evolved into what were called the "Foundation Courses.") Second-, third-, and fourth-year students were to concentrate on one of six workshops. Photography was part of the Light Workshop, along with film, commercial arts, and typography. This four-year course would lead to a degree in design. Two years of graduate study in architecture earned a student an architecture degree.

How the course of study was to be broken down was illustrated by the Figure Circle (see page 10). Within the Light Workshop photography occupied a unique position of importance. For the first time in a nontrade school, it was considered the equal of other disciplines, worthy of serious personal and artistic investigation. These firm roots gave the photography program a credibility that allowed it to predominate during the school's subsequent growth. Although popular belief holds that only the formalist mode was taught at the I.D., the program was always divided among the various photographic traditions: documentary, Constructivist, experimental, and purely formalistic modes.

Moholy was not only an educator-administrator, designer, and sculptor, but also an experimental photographer. Consequently, he was the first photographer to become the director and principal motivating force behind an American institution of higher learning. In his best-known statement— "The illiterate of the future will be the person ignorant of the use of the camera as well as of the pen" (*Telehor* 1, no. 2, 1936)—Moholy established a rationale for placing photography on a high intellectual plane. For his grand mission, "to educate the contemporary man as a new designer and integrator of the elements of art, sciences, and technology" (*The New Vision*, rev. ed. 1947, p. 177), photography was the perfect vehicle.

Harry Callahan, Aix-en-Provence, France, 1957

A great hindrance to self-expression is fear. . . . Fear is increased by an anachronistic system that teaches the student that he must walk in the shadow of the genius of the past. In the School of Design, the student must "strike down to bed rock" and build upward for himself, within himself, gaining that happy status of self-expression and experimentation which is the true science of creative achievements. School of Design catalogue, 1939–40

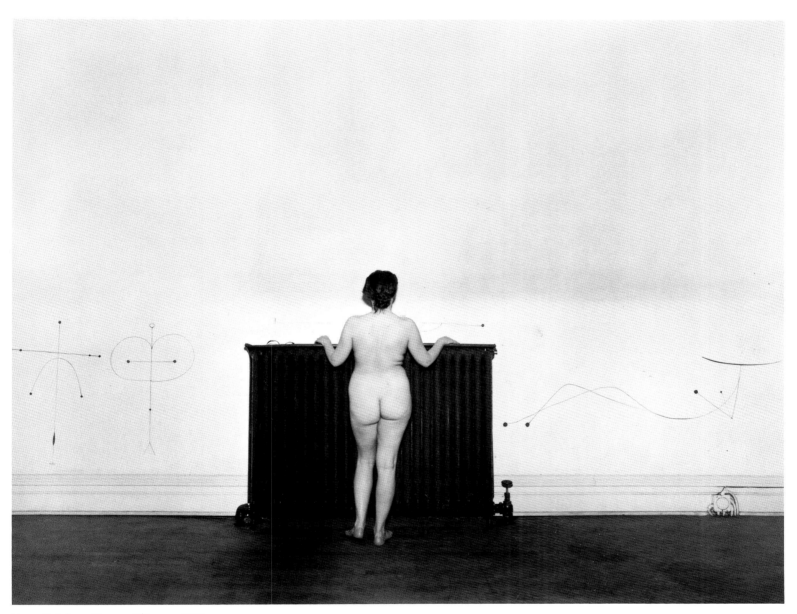

Harry Callahan, *Eleanor, Chicago, 1949*

25

Harry Callahan, *Chicago*, c. 1949

Harry Callahan, *Chicago*, 1950

It's the subject that counts. I'm interested in revealing the subject in a new way to intensify it. A photo is able to capture a moment that people can't always see. Wanting to see more makes you grow as a person and growing makes you want to show more of life around you. In each exploration or concern for the subject, I continue in the area for a great length of time.

 Harry Callahan, c. 1977

Years before he came to the United States, Moholy had stated his reasons for exploring the potential of experimental photography, both in his own work and in his educational program:

—In the photography of earlier days the fact was completely neglected that the light-sensitivity of a chemically prepared surface (glass, metal, paper, celluloid, etc.) was one of the basic elements of the photographic process. Nor were the potentialities of this combination consciously exploited.

For if people had been aware of these potentialities they would have been able with the aid of the photographic camera to make visible existences which cannot be perceived or taken in by our optical instrument, the eye: i.e., the photographic camera can either complete or supplement our optical instrument, the eye. . . . We have hitherto used the capacities of the camera in a secondary sense only. This is apparent too in the so-called "faulty" photographs: the view from above, from below, the oblique view, which today often disconcert people who take them to be accidental shots. The secret of their effect is that the photographic camera reproduces the purely optical image and therefore shows the optically true distortions, deformations, foreshortenings, etc., whereas the eye, together with our intellectual experience, supplements perceived optical phenomena by means of association and formally and spatially creates a conceptual image. Thus in the photographic camera we have the most reliable aid to a beginning of objective vision. Everyone will be compelled to see that which is optically true, is explicable in its own terms, is objective, before he can arrive at any possible subjective position (*Painting, Photography, Film,* 1925, repr. 1969, p. 28).

For Moholy this idea united the humanistic and technological concerns in his photography and educational programs. He was concerned with the pure photographic qualities of light, form, and texture, and at the same time preoccupied with optical perspectives—close-ups, selective focus, worm's-eye and bird's-eye views—on personalized subject matter.

Henry Holmes Smith, who has always admired Moholy's early writings, was hired as a photographic technician for the New Bauhaus after a chance meeting with Moholy. He taught the first class devoted exclusively to photography at the school. (Gyorgy Kepes had instructed students in photographic methods as part of the Light Workshops he taught between 1937 and 1941, assimilating Moholy's and his own ideas in the study of two-dimensional forms using "light modulators" and photographic materials.) The curriculum was later outlined by Smith and Moholy in a School of Design catalogue in 1938:

—The School of Design introduces tasks from a new point of view in order to stimulate the student's own approach. Thus photography is taught at the start without camera, using instead only photo-sensitive emulsion, creating photograms.

This is the real key to photography. The next stage is to make a "light modulator" from a sheet of white paper as the principal material. Every student designs such an object to work with a single light source. As the planes of the light modulator are curved or straight, bent or perforated, light play results which may be translated by photography with camera into a series of black, white and gray gradations.

The next stage is the study of light volumes (light as subject matter) as a genuine means of expression. After this . . . , the student goes on field trips and learns to distinguish between structure, texture and surface aspects. He learns about superimposed images, multiple exposures, negative prints and principles of solarization, photomontage and color photography. After these studies, he works with motion picture cameras.

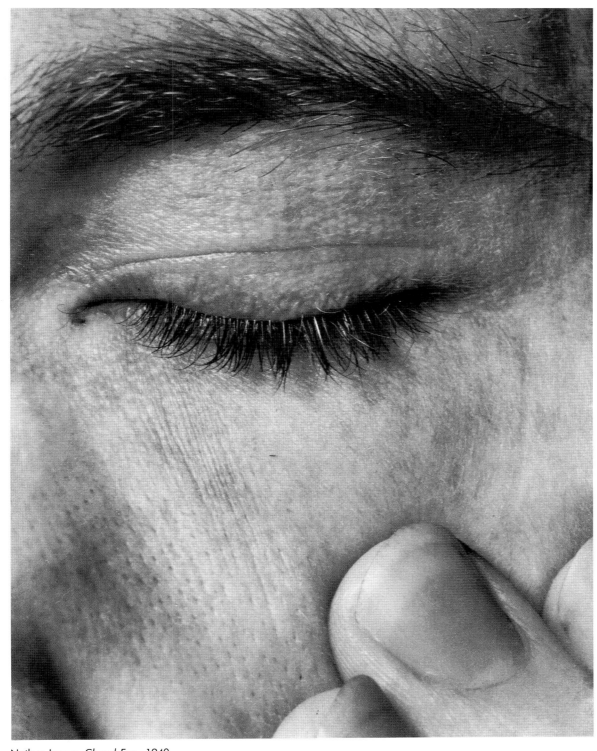

Nathan Lerner, *Closed Eye*, 1940

The specifics of the student's attention were covered by Moholy in "The Eight Varieties of Photographic Vision" (see page 15).

Smith sees his role as subordinate to Moholy's, applying Moholy's conceptualization in a practical, hands-on fashion.

—We look back on the New Bauhaus as rather a productive idea—at least a very productive educational experience. I realize how loosely organized an institution it was. It revolved around the energies of teachers and the kind of charisma that Moholy and others were able to give it.

For me the basic idea in Bauhaus instruction was the relationship of a human being through his sensibilities and his senses to a material, without the intervention of cultural preconditioning. For once in their lives people, right after the war, could be introduced to a sense of working that was free from cultural indoctrination.

No one in this time can appreciate the repression that was the twenties and thirties—sexual, political, and aesthetic repression, not to mention the general stupidity. In Moholy's book *The New Vision* I found the interaction and the material in the human being. Look at the diagram in *The New Vision* showing the potential of human development and how it can be dealt with. This is what was important—the potential of interlacing all the human capacities.

Moholy was also very interested in the documentary. I never got the notion that aesthetics were his primary concern. I don't mean that he wasn't involved, but I don't think he would have gone the way, say, of an Edward Weston. He was eclectic to the extreme. He told me he was a painter, not a photographer, when I first met him. Even I, naïve and idealistic as I was, who admired the man greatly, could see he didn't know a great deal about photography.

The lack of money at the New Bauhaus, the unbalanced student-teacher ratio, and the overscheduling of classes diverted attention from the fine points of photographic art. The vitality came not from aesthetics, but from the personal interaction between students and teachers. Again and again, later generations of students have mentioned the resulting communal feeling as a dominant characteristic of the I.D. Many important contemporary photographers studied at the school, and the strength of their work reflects the support they received in their pursuit of original ideas and personal perspectives.

The New Bauhaus closed after one year when it lost its funding from the pragmatic Chicago businessmen who had initially supported it. It reopened in the middle of the following school year, 1939, as a nonprofit institution, the School of

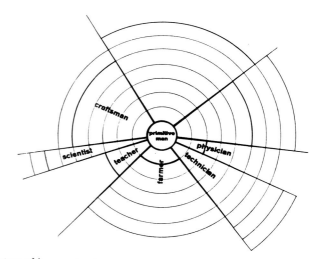

Sectors of human development

Design, on Ontario Street. Moholy had to dip into his own pockets, but he also had the backing of the Container Corporation of America's chairman, Walter Paepcke.

The first School of Design class of eighteen full-time and eighteen evening students included Nathan Lerner, who was

30

to become head of the photography workshop (1941–43) and in the second semester Arthur Siegel, who later chaired the photography department.

Nathan Lerner's experience was typical:

—The teachers were there not to tell you what to do but simply to tell you about their own experiences and to serve as a sounding board to encourage experimentation. That was the only way they felt you really could find yourself—by understanding the world through your senses.

Moholy nursed the school through World War II, when students as well as faculty who had not been drafted worked at solving design problems for the military. At the end of the war, the school was in danger of folding again because of lack of students, but it squeaked through, rescued by ex-servicemen and the G.I. Bill.

Stressing the difference in the school before World War II and after it, when he became dean of faculty and students and head of the Product-Design Workshop, Lerner notes that in the early years, photography was not yet taught as a discipline with its own aesthetic but as one of many equal ventures. In his interest in light as subject matter, however, he emphasized self-reflective and formalist concerns of Moholy's New Education. Moholy's ideas were particularly appealing to students of the fifties, sixties, and seventies, who were more interested in photography as art than in commercial photography.

Dispensing with conventional pictorialism and the illustrative uses of photography in the Foundation Course expanded the limits of what could be regarded as subject matter. According to Lerner:

—In the forties commercial photographers came to the school. They thought they could learn new tricks. When we started them with photograms, they sneered, "This is abstract art; it doesn't mean anything." Then they

Arthur Siegel, *Photogram*, 1947

found they were responding to forms that had nothing to do with subject matter. They realized that subject matter without a proper vehicle could lose its significance.

The idea of subject matter was put into its proper place. It became part of a total image. I think an honest image expresses itself in proper balance, both the visual and the inherent emotional content. In giving visual fundamentals, the school was giving the students the vehicle for encapsulating the expressions they wanted to give.

Gyorgy Kepes, whose teaching and special ideas were fundamental to Lerner, saw reflected in Lerner's own work two of the key ideas of the school: interest in creative light abstraction and humanization of art. His photographs "are always infused with social insights, human sympathy, and sug-

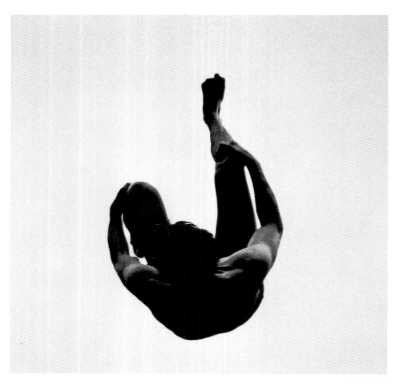 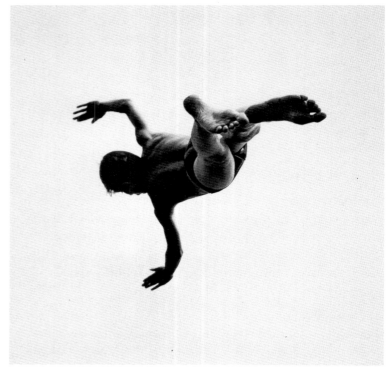

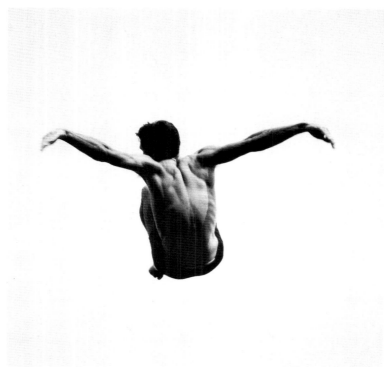 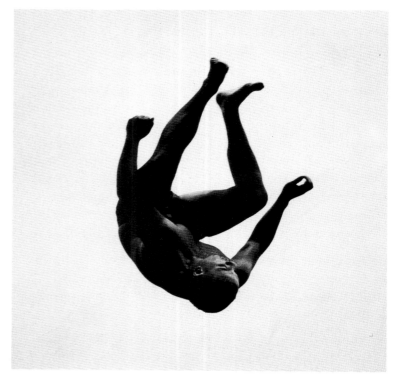

Aaron Siskind, from the series *Pleasures and Terrors of Levitation*, 1953–56

A picture is not something that is completely or objectively willed into existence. A picture is the result of a conjunction of circumstances of which the photographer is one. A picture is basically not a statement of what you believe, but rather a kind of indication of what you might believe or what you didn't know you believed.

Aaron Siskind, 1978

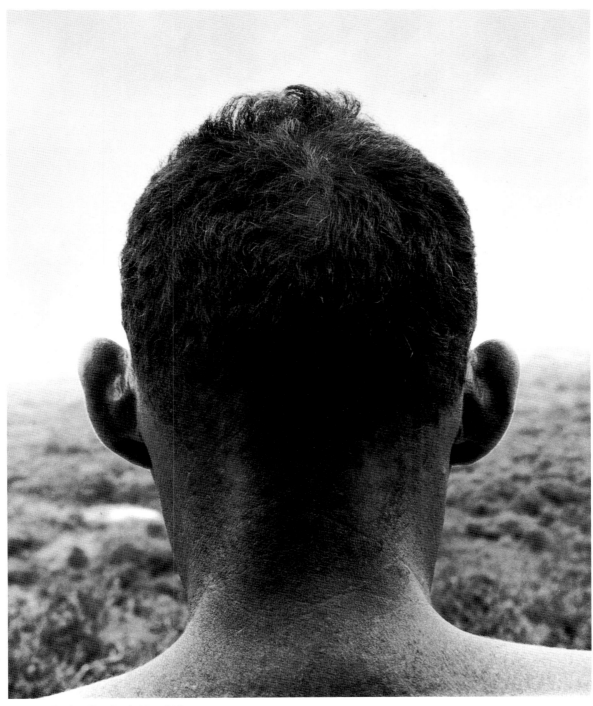

Aaron Siskind, *Bill Lipkind, 27,* 1960

gest a wholeness of vision that we all seek" (*Nathan Lerner*, 1976, p. 1).

At the same time the course of study encompassed the documentary form, as well. Moholy continually stressed the value of the camera's pure optical vision (he had made several documentary films and a photographic study in England before coming to Chicago), and he underlined the importance of reportage as one of his eight varieties of photographic seeing. Nathan Lerner had photographed Chicago's Maxwell Street slums before his student days and made similar pictures later on. Arthur Siegel (who was involved with the school on and off until his death in 1976) was a free-lance photographer in Detroit before becoming a student, and turned to photojournalism afterward. His documentary pursuits coincided with the larger social mission coming out of the Bauhaus ideas that were taught elsewhere in the school.

The upheavals and strains of depression and war produced a political consciousness in the students and faculty that they expressed in photographs. The documentary form was in fact combined with formalist concerns. John Grimes points out that Arthur Siegel championed this unity throughout his career. Siegel had been schooled in sociology and later was a member of the FSA and the Office of War Information as well as a photographer for *Life* and *Time*. He applied a social, analytical, and technological perspective to the teaching of the history of photography and to experimental photography.

In early 1946, after serving in the Signal Corps, Siegel returned at Moholy's request to head the photography department. About this time, the School of Design moved to new quarters on Dearborn Street and was restructured and renamed Institute of Design. Siegel retailored the program, in line with Moholy's ideas, to accommodate the increased enrollment. Because the veterans were concerned with occupational goals, the curriculum was geared more to commercial interests. A Bachelor of Arts degree in photography, not just design, was now granted after four years' study. A fully accredited master's program was soon offered. Visual fundamentals, workshop product design, art history, mathematics, sociology, and economics were added to the curriculum. In 1976, shortly before his death, Siegel characterized the department's objectives, which he felt were unchanged:

—Our primary concern is the development by the student of a mature creative philosophy of photography. This goal is implemented by an intensive training in contemporary technique and practice. The student studies the history of photography from the aesthetic and scientific points of view. The relationship of photography to the cultural atmosphere in which it operates is analyzed. Both contemporary and historical subject matter are discussed with an eye to their implications for the future.

Siegel added more intellectual content to his teaching than had been evident at the school during the thirties and early forties. His lectures included "Semantics and Language of Photography," "Relationships of Creative Photography to the Structure of the Mind," and "Photography: A New Tool in Case Work."

In the summer of 1946, just before Moholy died, Siegel organized a landmark symposium on photography that included Berenice Abbott, Erwin Blumenfeld, Beaumont Newhall, Ed Rosskam, Paul Strand, Roy Stryker, and Weegee as participants. It was the first time that the many varied interests of creative and fine-art photography had been brought together in such a venture. (This program became the model for the workshop idea popularized in the sixties and seventies.) To the Bauhaus milieu, the symposium introduced the classical and straight approaches to camera work and contemporary approaches to advertising and commercial photography. The secular Bauhaus traditions of European-oriented experimental photography were integrated with the somewhat more catholic view that was gaining ground in the

United States. The assembly recognized the growing community of serious artist-photographers and underscored the school's turn toward the study of a pure medium and the

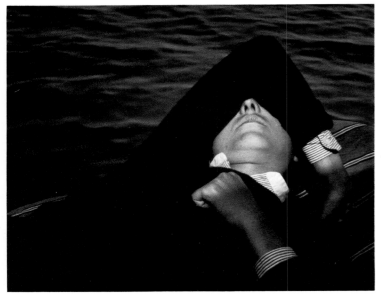

Nathan Lerner, *Girl in Boat*, 1935

development of a genre of photography concerned with the aesthetics and history of photography.

Despite his enthusiasm, intellect, and the respect of his students, Siegel was not a popular or charismatic teacher. He was temperamental, dogmatic, and often condescending. After Moholy's death, Serge Chermayeff, an architect, became director of the I.D. Siegel found him to be an antagonist, and the two men quarreled frequently despite a common intellectual aloofness. Siegel subsequently turned more to commercial work and lessened his teaching load. (He taught part time intermittently until he again became a full-time employee in the late sixties.) Siegel made these comments about his own career:

—There were periods when I resented not having the time to go and do my own photography. Overcoming

that, though, was the belief that I had an educational mission. There were no photographic courses of study in America or in the world, except probably scientific ones. What I am proudest of in my life is not my photography, but my educational contribution. I put together what was probably the most influential photographic course of study in the world. The only course like it—not *like* it, but competing—was what Ansel Adams was doing. I was incorporating part of that in my program—in the straightness, the control, the technique. Ansel doesn't know anything about real photojournalism. I was a photojournalist bringing together all of these concerns.

Siegel's views of the period were not always shared by his colleagues. Lerner and others certainly contributed to the synthesis of ideas which became the postwar program.

Henry Holmes Smith recalls what he felt happened in the late forties:

—When Chermayeff fired many of the old bunch, he killed the continuity with the old Bauhaus ideas. It could only have been Arthur who actually carried them forward.

Concerning the survival of the photography curriculum under the new administration, through the 1950s, Smith says:

—I think it is because of Aaron Siskind and Harry Callahan that photography survived, and not Siegel. Siegel put the history in. I don't think Harry really cared about history—he was more interested in picture making. If anybody actually taught the aesthetic principles it would have been Aaron.

In 1946, just before Moholy's death, Arthur Siegel invited Harry Callahan to teach basic courses in photography and join a faculty that included Ferenc Berko, Wayne Miller, Frank Levstik, and Hillar Maskar. Among Callahan's promis-

Event has been a key term for the way a photograph has to work for me. It's been with me a long time. That certainly was important in the Loop, where I would see the street activity. Then I would see relationships developing, and I would feel something fall into place. It wasn't that I said, isn't that a nice arrangement? It was a sense of the tension, of knowing that things were moving and also that the tensions were right and that was it. After awhile it could simply happen with light. It would have that sense of something coming into place where it wasn't at rest — it wasn't going to be there in a permanent way.

Ray K. Metzker, 1978

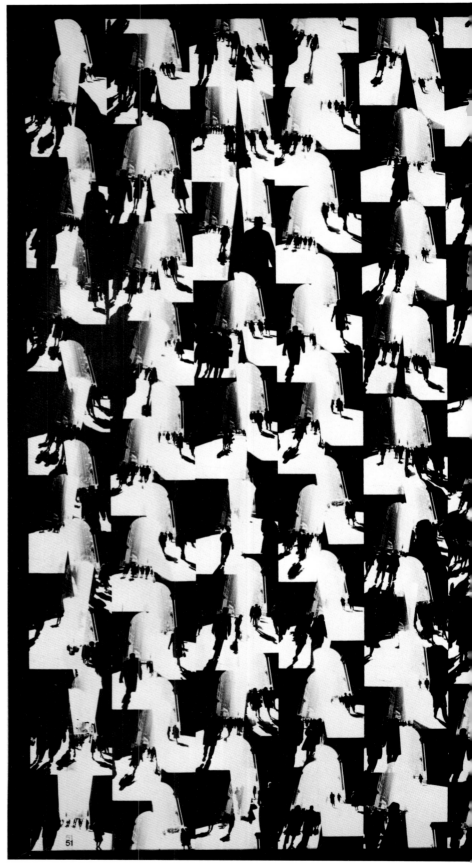

Ray K. Metzker, Arches, 1967

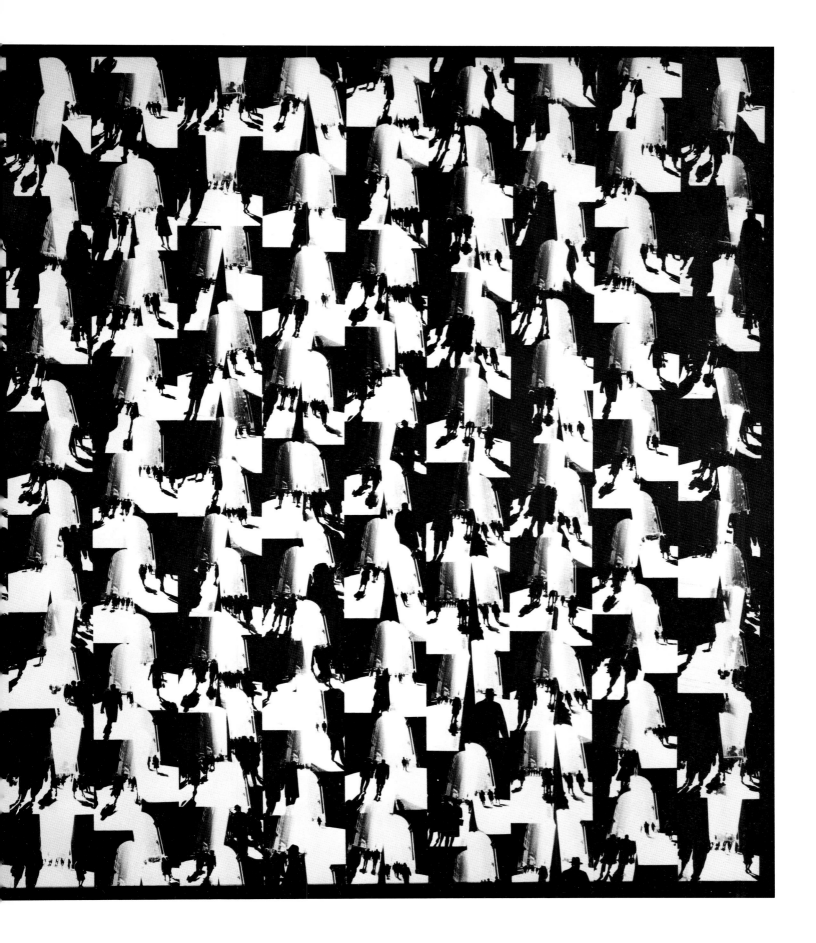

Joseph D. Jachna, *Door County, Wisconsin, 1970*

Photographers today are interested in maintaining a special equilibrium. . . . At one end, the commonplace aspect of the subject matter dominates the picture, a public image results, and the intensity of the experience of the artist is diminished. At the opposite extreme, the photographer's private imagery obscures the subject matter; viewers then lose faith in their ability to deal with the picture and abandon it before they have a chance to see it.

Henry Holmes Smith, 1961

ing early students were Art Sinsabaugh, Bert Beaver, Davis Pratt, Yasuhiro Ishimoto, and Marvin Newman. Siegel explained why he hired Callahan:

—I always thought Harry was a wonderful photographer. He was, and is, directed toward success. What he did photographically in one weekend is what anyone else might do in ten weekends. He went through periods when he repeated himself, but he had to go through them. In many ways Harry is a very simple person: his photography is simple and his themes sophisticated. He wasn't a reader or an intellect, but a fantastic, creative photographer. Harry is smart in his simple-minded way. He is not innocent. He was the perfect example of the consummate working photographer and artist—what the students needed as a guide.

Siegel had known Callahan since the early forties when both were members of the Detroit Photo Guild. Siegel had returned to Detroit to lead the Guild following his studies at the School of Design, bringing with him many of its ideas. John Szarkowski recognizes Callahan's indebtedness to Ansel Adams during this period for exposing him to the sense of order and majesty in his craft, but does not document the importance Callahan now attributes to discussions of the Bauhaus ideas in Detroit (*Callahan*, 1976, n. pag.). Callahan's Guild experiences persuaded him to experiment with the multiple image and sequence.

Siegel annoyingly claimed that he was the source of Callahan's success. Callahan expresses an indebtedness to Siegel for giving him the opportunity to pursue his visual passion as a vocation, but it is clear that Callahan built his reputation through his own talents. His native genius and already developed style flourished when he came in contact with committed artists such as Hugo Weber and Mies van der Rohe (who was in charge of the Illinois Institute of Technology's architecture program when the I.D. joined that institution in 1949), and an atmosphere that was both supportive and receptive

to his work. Despite his shyness, inarticulateness, and inexperience as a teacher, Callahan was a happy choice for the post.

Art Sinsabaugh came to the Institute of Design as a student just before Callahan was hired. (Sinsabaugh subsequently

Kenneth Josephson, Honolulu, 1968

became Callahan's friend and fellow teacher during the early 1950s.) He describes Callahan in the late 1940s at the I.D.:

—Many of us had high aspirations, not to make money but to be special in terms of ideas. Two-year students just back from the war wanted to learn commercial things. People like me must have driven them up the wall. This was an elitist school, a private, everybody-dedicated school—with a lot of commercial photographers. The influence of these people was changing the old qualities. Even Arthur Siegel had that kind of attitude: he represented himself as a working pro, legitimate both artistically and monetarily. He says he brought Callahan in because Callahan represented the other alternative, the photographer committed for purely creative reasons.

Callahan respected Siegel for what he was trying to do, but it disturbed him when Siegel claimed to be his teacher. Callahan took great pride in not having been

Art Sinsabaugh, *Midwest Landscape #29*, 1961

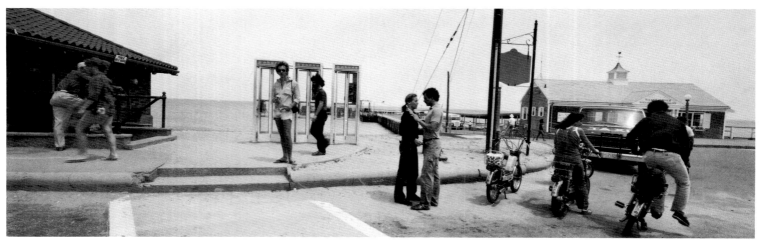

David Avison, *Oak Bluffs, Martha's Vineyard*, 1978

William Larson, *The Figure in Motion*, 1969

Barbara Blondeau, detail from *Karen Series*, 1972

Linda Connor, *Untitled*, 1968

Thomas Barrow, from the series *Pink Dualities, Pasadena Palms*, c. 1974

trained by anybody. He taught in a mild-mannered, hesitant way. He would assign a problem—to photograph people without people in the actual picture, for example—and at the end of the class wander off and try it himself. He worked on all of the projects he assigned. When you came up with something that he hadn't thought of he was amazed—even happy.

He taught technical problems that were really visual problems, like the "sky" problem: to make a negative that was eighty-five percent sky—a pretty minimal subject. You had to use the sky as a nonimage.

Arthur Siegel claims he organized the program at the Institute of Design, but I know what Harry and I did and what Harry must have done before I knew him. All the real organization, the organic flow, was Harry's. As I said, there was a lot of elitism—emotional ascetics, intellectual ascetics, etc. I think Harry was against the elitism.

It was a period marked by change. In 1946 the I.D. moved from State Street to the Dearborn Street address. In 1947 Henry Holmes Smith left to teach at the University of Indiana, carrying the I.D. tradition with him. Then in 1949 the I.D. was amalgamated with the Illinois Institute of Technology. After Moholy's death, Chermayeff fired many of the old faculty. With Siegel gone, Callahan became head of the photography department. Those remaining resented the loss of the school's intimacy and its purer "New Vision" aesthetics. Consequently, political infighting forced Chermayeff to leave in 1951. As chief administrator, Jay Doblin, a designer, replaced temporary director architect Crombie Taylor.

As a naïve "academic," Callahan characteristically—perhaps unconsciously—avoided the contentious administration. Seeing himself more as a photographer than as a worldly educator, he focused as a mentor almost exclusively on the specific concerns of photography. In this he deviated from his predecessors and colleagues. His growing reputa-

tion as an artist and his single-mindedness earned the photography program more respect than it had ever had before, and more students entered with an expressed desire to study

Aaron Siskind, *Harlem: Most Crowded Block,* 1939

photography as an art form. After the I.D. joined the Illinois Institute of Technology, its master's program in photography, begun by Callahan, was directed solely to this end. Consequently, as the photography program and the I.D. grew, the possibility of integrating photography with other curricula diminished.

Callahan's work was marked by the precision of a classic printmaker, which represented a significant technical change at the I.D. Callahan, while sympathetic to many of the Bauhaus ideas about photography as a medium of tone and texture, actually led the program away from such rigidity:

—I never felt I was part of the Bauhaus stuff, but I really did like the Foundation Courses. If I hadn't, I doubt if I would have been able to last. I still don't believe you can teach anybody to be creative. All you can do is give them an environment. The Foundation

43

Kenneth Josephson: above left, *Chicago*, 1967; right, *Chicago* from *History of Photography Series*, 1976; below left, *Stockholm*, 1967; right, *Illinois*, 1970

44

Course allowed you to talk about photography and you didn't have to go into a lot of b.s. about what art is—"Is that texture?" or "Is that tone?"

The strongest emphasis was on form, powerful form—interest in found objects. I could see the students walking out with their work, and I felt bad. Everything was Bauhaus this and Bauhaus that. I wanted to break it. I tried to give them as many different viewpoints as possible. I got tired of experimentation. I got sick of the solarization and reticulation and walked-on negatives. What I was interested in was the technique of seeing.

When I became the head of the department, I figured out a little plan. The students would experiment in the senior year—the first half in whatever interested them, the second half in a specific project. I thought the students should take the Foundation Course, which dealt with photography in the abstract sense, then start slowly to get into their own thing. I introduced problems like "evidence of man," and talking to people—making portraits on the street. Talking to people nearly killed some students, but I thought they should enter into dealings with human beings and leave abstract photography.

I felt that social photography would be the next concern. Then Aaron Siskind came. He broke down photography into portraiture and architecture and different traditions. I hoped that in the last year a student could find his own way, which is a lot of crap, but a good attitude to foster.

Callahan developed his ideas into series, groups, and extended bodies of work. His methodology enlightened his students, and it laid the foundation for the thesis project the photography program later required of its graduate students. The creation of a group of related photographs—a synergism of experience with photography—was the mainstay of photographic education at the Institute of Design for the next twenty years.

Callahan explains the evolution of his manner of working:

—I can trace back the series idea to Ansel Adams. When I first saw his pictures, there was a wave se-

Aaron Siskind, *Kentucky,* 1961

quence. I was photographing and all of a sudden I did the same thing, but unconsciously. Really crazy. From then on I did things my way. When I came to the I.D. I found that others were working in series, too. Marvin Newman, for instance, made his graduate project "the series." He did it in all kinds of different ways: in terms of time, background, all kinds of things. We had students choose a similar form, a similar subject, and make a series. The series gave rise to the thesis, which was really an enlarged series. I have always felt that all of my work was the series.

What photography does best is to make possible an easy presentation of a life's work. Other media do it—you can collect all of Beethoven's works on records—but Van Gogh . . . God! When do you get a chance to

see all of his paintings together? I think photography lends itself to that process of assembling beautifully.

In 1951 Callahan hired Aaron Siskind to replace Wayne Miller as teacher of documentary and socially concerned photography. Callahan saw Siskind as a totally different photographer from himself in approach, but one who was complementary artistically and compatible personally. The timing was fortuitous. That same year Arthur Siegel gradually had to reduce his teaching load because of nervous strain. He left in 1954 to concentrate completely on commercial photography. (Siskind's hiring coincided with another period of dwindling enrollments marked by the demise of the G.I. Bill. Money was so scarce that Art Sinsabaugh, valuable as he was, was fired.) Siskind had a reputation for his abstract photographs and had exhibited them in New York, but Callahan knew Siskind's documentary work through the New York Photo League, his production of the "Harlem Document," and a later architectural study called "Tabernacle City." Ironically, almost as if it were destiny manifest, Siskind fulfilled Moholy-Nagy's vision of the ideal artist as described in *The New Vision:*

> ——The function of the artist in society is to put layer upon layer, stone upon stone, in the organization of emotions: to record feelings with his particular means. The artist unconsciously disentangles the most essential strands of existence from all the contorted and chaotic complicities of actuality, and weaves them into an emotional fabric of compelling validity.

Moholy could easily have been describing Siskind's *Martha's Vineyard Rocks* or *Clap Board Fences of Harlem, Kentucky*. Siskind's approach to pictorial surface, although from a less structured orientation, deals with many of the I.D. canons concerning tone, alteration, and negative/positive space. He radicalized the medium by shifting focus to a flat plane, alluding to optical depth in the reconstructed surface of the photograph. The vision harmonized perfectly with Moholy's

ideas on changing the camera's point-of-view and on the creative possibilities in translating the three-dimensional to a flat plane by means of camera optics.

Though Siskind never envisioned himself as a charismatic leader, he nevertheless closely resembled Moholy in his breadth of interest and skills. A fine artist, able administrator, conscientious educator, and intellectually curious individual, he inspired admiration in students and faculty alike. Combined with Callahan's dedication and intent, Siskind's generosity of spirit encouraged students to engage in photography as a way of life.

With the influx of post-war-baby students in the late fifties and early sixties came a period of relaxed economic and political tensions that fostered the academic and artistic pursuit of photography and popularized it as never before. A more diverse, even artistically naïve, group of people now had access to the professional camera. Ironically, the same technological society that increased interest in the camera and perfected its machinery also alienated the student. The new student demanded individualistic and expressive outlets, not just career training. Enrollment at the I.D. again swelled as students rejected traditional, career-oriented curricula for a personally stimulating and liberated education. The Bauhaus model already held the seeds for such an education. Siskind and Callahan, with their dedication to personal creative pursuits, used these formulas to evolve a new, vital program. The growth of their friendship and the mutuality of their vision intensified their purpose.

Siskind's career and experience directly affected the changes Callahan had initiated as head of the department. With twenty years' experience as a public-school teacher, Siskind could solve the administrative and structural problems of a growing department. With his natural assertiveness, he easily codified and organized the department's objectives and curriculum, freeing Callahan from the responsibility for most of these details. Siskind taught the methods of teaching, and

Barbara Blondeau, *Victim* (glass negative), 1966

Richard Nickel, *Demolition of Proscenium Arch, Garrick Theatre*, 1961

Nothing essentially new has been discovered in the principle and technique of photography since the process was invented. Every innovation since introduced — with the exception of X-ray photography — has been based on the artistic, reproductive concept. Every period with a distinctive style of painting since then has had an imitative photographic manner derived from the painterly trend of the moment. László Moholy-Nagy, 1947

Barbara Crane, from *Chicago Loop Series,* 1978

I have always felt that photographs are quite simple realizations of rather complex human experiences of all kinds. As objects, they are about as unprepossessing as they can be; light in weight, paper thin and generally small enough to hold in your hand. Yet, they engage the mind and soul in a way no other traditional art object seems able to do. They are, I would say, monumental in this respect. William G. Larson, 1978

Thomas Barrow, *Censorial Sparkle*, 1968

Thomas Barrow, *Reciprocal Ovum*, 1968

his students in turn propagated the program's ideas across the country:

— I was more pedagogically oriented and more comfortable in making up a program than Harry. One of his big ideas was going on location. I picked up that idea and took a group of students down to the auditorium building and had them photograph it. That's where the [architectural] project began.

We were one of the few schools around for a long time. Lots of the students who came to us were interested only in photography. The ones who had a commercial bent we helped train and gave them what information we could. Some went into commercial work, but most students just wanted to be photographers. The simplest way out was teaching. They picked up things from my teaching—the way I conducted a class influenced a lot of students. I had a good background in education and a great deal of interest in it, having put a lot of energy into teaching. There wasn't any level on which I wouldn't help [the students].

Second, Siskind's documentary experience brought together his formalism and the Constructivist ideas of the Bauhaus. The two traditions had been complementing each other in the school for many years, and Siskind combined them in his teaching.

— When I got to the I.D., I enjoyed the whole spirit of the place. It had a lot of creative energy, and I liked everything that was going on. Guys with ideas were working together, and there was still a residue of Moholy's influence—and a lot of quarreling. The Bauhaus system underlaid all the learning and teaching in the Foundation Course. These ideas were very strong for the first two years and affected everybody. The teaching had to do with exploration and investigation and with a delight in the use of materials. That spirit permeated the whole school, right into the seventies.

For a long time I was doing documentary work—social documentation—which was part of Moholy's work, too, although his documentary work was inferior. Moholy made documentary movies when he was in England, and Arthur Siegel made some, too. I remember one so documentary it was absolutely tedious—some people watching clocks move. In the student's final year he could choose practically any subject. I assigned an endless number of documentary projects.

My interest in documentation was in the way of making a picture according to certain principles, and in evaluating it to discover its meaning. I always stressed aesthetic values. In documentary I was interested in finding out what a picture was, what a realistic picture was, and how you could make it—you can only find out by making it. I wasn't particularly interested in stimulating students to become interested in social causes, but I thought it was a viable way of working. My job was to interest them in making pictures, in showing them what value photographs might have for them.

Siskind's other important contribution was the worldliness of his view. His origins were in the art world of New York in the time of the Abstract Expressionist movement. Siskind's magnetism and his articulate support of the development of photography for its own sake revitalized Moholy's New Education, which by the early 1950s had been misinterpreted by an uninspired I.D. administration.

Throughout the fifties and sixties the undergraduate program remained pretty much what Siegel had prescribed in the late forties. The graduate program under Siskind and Callahan was less rigid than the school's other programs, and it was incompatible with the general theoretical climate. By the late fifties other department heads agreed with the administration that Callahan and Siskind's program was entirely too aloof. The two photographers consistently refused to yield to a notion of education they felt was degenerating. For them,

the growing size of the school, its integration into the Illinois Institute of Technology, and the formal structures of a large multiuniversity threatened the ideals of the kind of education inspired by Moholy. As Siskind explains, Moholy's intimacy could only be maintained within the warm confines of a small unit like the photography department:

—There were aesthetic overtones. That is why the artists I knew in New York detested the Bauhaus approach—the application of the artistic sensibility to the everyday problems of man. In the sixties the I.D. essentially wanted to create "designers" in the broader sense of the word. Finally, Jay Doblin reorganized the whole curriculum. We could hardly talk about the photography department or the visual-design department. The administration decided how much from each area had to go into the total designer. Photography to them became a function of this designer.

They began to envision the time when the designer didn't need to draw anything; he merely had to know how to combine things. The product designers were no longer making models themselves, they were giving them out, and later on they didn't even bother with that. The whole exercise became a mental one. Naturally, the administration attempted to work photography into the system. Doblin's concept was that we were teaching students something pure and weren't willing to relate photography to other areas.

What was really happening was that they were degrading every area. If you reduce the quality of work in any one area or all the areas, you're not going to produce anything. You may create somebody who knows something about each area, but that person will not have any real quality to him, and he won't be the Renaissance man that you think you're creating. Sure, you have to relate these things and let them find out what's

going on in all departments. But the notion of creating an overall designer was preposterous, because the people in charge of the school hadn't achieved it themselves.

Everything was directed to organization. The humanity and the individual attention was going. In my thinking every human being has to have a center. When you're in school, you have to have a center of interest that all your other interests and all your values radiate from. This is a center in which you are proficient, about which you know a great deal, and which [gives you] a basis for evaluation.

Siskind elaborates on his and Callahan's teaching methods and on the structure they subsequently built:

—Of course in the fifties we didn't have so many students. Sometimes we didn't have enough students for a class, and would have to put two classes together. Later on, in the sixties, I had an enormous number of students. I would call a meeting and find a convenient time for another class in terms of the students' schedules.

In the last years, the department heads would say, "Siskind is off doing his own programming," which of course was nonsense. Since they wanted to integrate the school, they claimed I was disintegrating it, but I was always interested in what was going on in all departments—you could always find me in the product department looking at what was happening there. When I counseled students, I put them in a class here and a class there, outside of photography if they needed it. I even created courses for other departments—like a course for the product department to photograph surfaces and materials.

In 1961, after a ten-year association with Siskind and a fifteen-year association with the I.D., Callahan left the school, exasperated by the growing tension and bureaucracy im-

Geoff Winningham, *Pep Rally, Winston Churchill High School,* 1978

Michael Abramson, *Perv's House,* 1976

53

Yasuhiro Ishimoto, *Untitled*, 1950

posed by the administration. Like others before and after him, he took much of the I.D. curriculum to his new post as developer of the photography program at the Rhode Island School of Design. At the same time photography was becoming more popular and the number of graduate students was increasing. Aaron Siskind explains how he made his decisions on admissions:

> —I'd accept any student interested in doing work who had done some work. I put him into various undergraduate classes informally until he reached a certain level. Then we would start to work on his thesis. Later on we formalized the system, so that I would admit students with photographic "deficiencies." That was a practical, clever idea, because few students were coming out of a four-year photography course—or three-year course—in any other institution. Most of our students were self-taught or had studied for a year somewhere. That was the richness of it—students came from every discipline.

The ten years of the Siskind-Callahan partnership produced a new generation of photographers educated in photography as a fine art. Among them were Thomas Barrow, Barbara Blondeau, Lyle Mayer, Joseph Sterling, Ray K. Metzker, Linda Connor, Barbara Crane, William G. Larson, Keith Smith, Charles Swedlund, Joseph Jachna, Richard Nickel, Len Gittleman, Geoff Winningham, George Nan, and Kenneth Josephson, all of whom became teachers or directors of programs at the university level. Swedlund later wrote the first modern textbook integrating the history of photography as a fine art with technical concerns. During the sixties the I.D. family tree grew rapidly, as I.D.-trained teachers took their knowledge to students in other institutions.

The I.D. photography program received much attention in the photographic press (e.g., *Aperture* in 1961), and the students themselves published and exhibited regularly. Seri-

ous collectors and museums purchased The Student Independent Projects, portfolios of original prints, which helped to publicize the department and raise money for further student projects.

After Callahan left, Siskind acted alone as head of the department with the help of Joseph Jachna, a former student. Occasionally Arthur Siegel taught his now-refined Freudian interpretation of the history of photography, which had become his pedagogical preoccupation. His analytical approach complemented the looser hands-on, supportive attitude fostered by Siskind. The program embraced the diverse

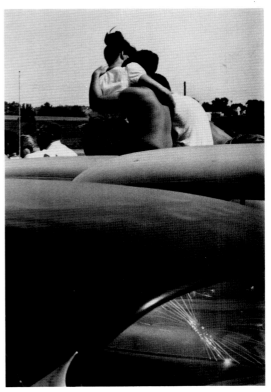

Joseph Sterling, *Untitled*, c. 1964

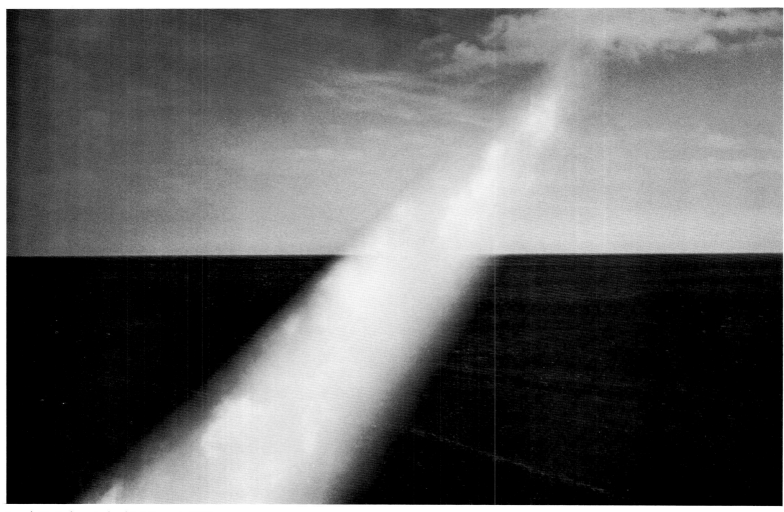

Joseph D. Jachna, *Iceland (at Nupsa)*, 1976

The making of a photograph is an act of intelligence and an act of discovery. . . . A photograph often has a counterpart in life, in music, a poem or song, but these are never substitutes. The photograph is its own full explanation, and the joy of it is to look at it. Joseph D. Jachna, 1969 — 70

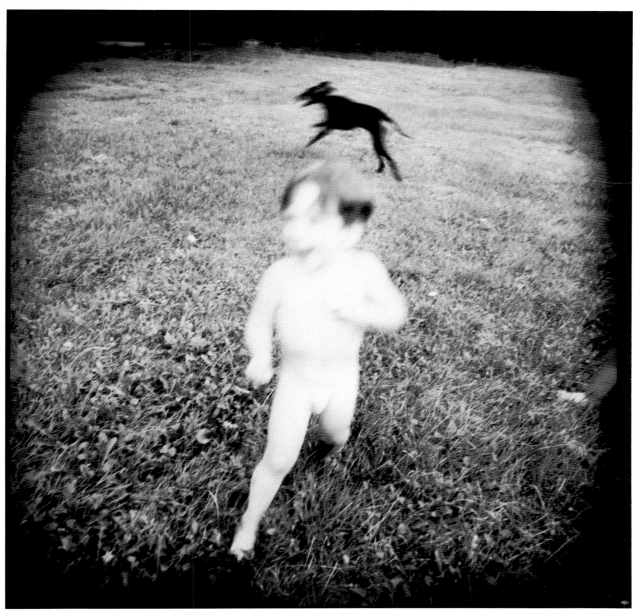

Charles Traub, *Aaron and Dog*, 1973

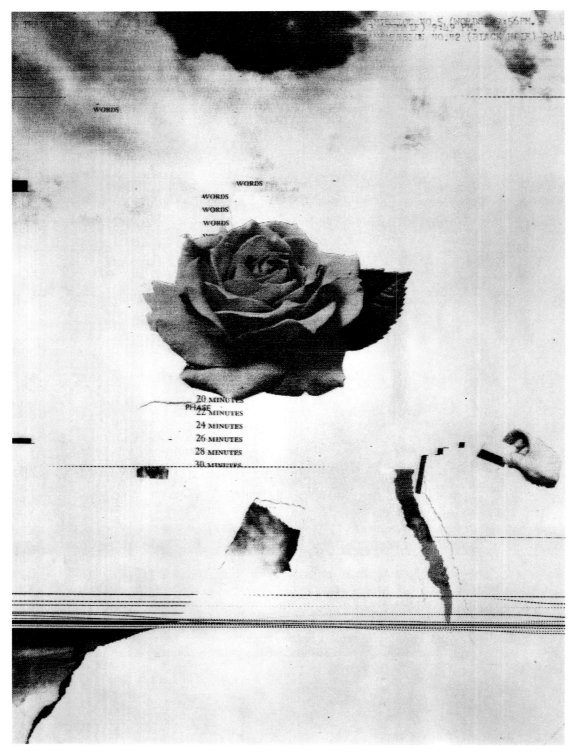

William Larson, *Telephone Transmission,* 1975

The enemy of photography is the convention. The salvation of photography comes from the experimenter who dares to call "photography" all the results which can be achieved with photographic means with camera or without. László Moholy-Nagy, 1947

and growing community of serious photographers by inviting several of them to the school as visiting artists. Nathan Lyons, Wynn Bullock, and Frederick Sommer all taught at the school during the sixties. Again in 1967 Arthur Siegel was hired by Siskind on a full-time basis.

Throughout the sixties and seventies the foundation curriculum of the undergraduate school included the beginning two semesters of photography. Graduate photography students educated in disciplines other than art and design took the Foundation Course in photography with undergraduate students. The basic Bauhaus problems, including the "light modulator," "virtual volume," and "series," were still given to the students, as well as Callahan's problems. Siskind added several problems of his own:

—I used to give students what I called a "copy" problem to check up on certain basics they needed to know in order to go on. They copied—on a flat surface—a black-and-white continuous tone (like another photograph), a black-and-white noncontinuous tone, and a color picture that had a great many colors that relate to continuous tone. The presentation had to be the original with the copy, side by side.

Another problem was called "significant form." I had the students go to a greenhouse and photograph plants. I showed them examples: you can photograph a plant so that you plainly describe it; you can photograph the plant so that you have a quarter of an inch in focus and all the rest out, a poetical decision; and you can photograph the plant as a pure form. You can break it down many ways. I liked that problem because it made students conscious of basic things in art, with the transformation of an object into an aesthetic thing based on form.

I even made a whole series of problems to combine the architectural discipline of the school with photography.

Critics castigated the program that evolved during the Siskind and Callahan years for having propagated a style of formalism known as the "Chicago School." Typically, the teaching stressed a concern with composition (what went on in the picture frame) and the creative use of the picture frame to transform subject matter and objects into expression. Siskind elaborates on this concept in reflecting on the similarities and differences of several of his students:

—How can you compare the work Tom Barrow did with the kind of work that Geoff Winningham does. Altogether different. But I imagine there are some similarities. I suppose if you have a group of people week after week come in and show you pictures, you are bound to see some similarities. They have to take pictures that have certain formal consistencies and relationships.

For instance, in one class I had Barbara Crane, Tom Barrow, and maybe one or two others who faded out. They were permitted to use any means to take a picture. Barrow did a simple, symbolic kind of a thesis. He photographed the evolution of the automobile: the beautiful car in the showroom, the automobile on the road and the people in it—formalized pictures of heads of people—and then the destruction of the cars. He alluded to paradise and expulsion from it. At the same time, Barbara Crane was making formal studies of the nude. She was trying all sorts of things because she hadn't found her way yet. She was always trying—but when she made a straight picture, it was meaningless—so she tried various kinds of things—combination, infrared, etc.

After a twenty-year tenure at the I.D., Siskind was forced into retirement in 1970. Weary of the lack of respect the administration had for him and his contribution, he joined his friend Harry Callahan at the Rhode Island School of Design. During the sixties Siskind guided the graduate program at

John Wood, *Untitled*, (photo collage), 1970

John Wood, *Untitled* (photo collage), 1978–79

61

I.D. and influenced an unparalleled number of promising students, including Tom Barrow, William G. Larson, Keith Smith, Linda Connor, and Eileen Cowin. The graduate stu-

Mary Lloyd Estrin, *Untitled*, 1975

dents of the sixties and early seventies mingled with a new community of photographers who emerged all over the country. They came to the school from diverse backgrounds with a photographic dialogue and language that had little to do with the anachronistic New Bauhaus concepts.

After he was rehired in 1967, Arthur Siegel talked of the importance of producing a body of work that would expand knowledge of the medium. He insisted that work be "fresh" and pushed students constantly to "do something new." He praised the avant-garde and discussed relevant contemporary ideas and their importance to photography. While Siskind provided students with a personal value system, Siegel intellectualized the medium.

The first students of the seventies who entered the I.D. were attracted by the enthusiasm and acclaim of its recent graduates. The pressure on students increased with enrollment. Art

schools all over the country competed for graduate students, and students calculatingly prepared for recognition as artists and fought vigorously for scarce openings as teachers.

The Foundation Course problems continued to be the same, with the emphasis on the graduate critique and the creation of a thesis body of work. Although the parameters of the thesis became in some ways academic as a result of entrenchment in its own traditions and history, the actual process was much as Siskind had described it in the sixties. After his departure, the faculty increased emphasis on the literature and history of the medium, fashioning a graduate program that left little time for integration with the school's design or architecture departments. An awareness of Moholy's ideas and the New Vision of photography existed but was not cultivated by classroom discussion. Yet continual emphasis on problem solving accentuated the experimental-technological aesthetic and the formalist concerns of the medium.

Eileen Cowin, *Untitled*, 1971

By 1971, Arthur Siegel was again head of the photography department, with his authoritarian manner dominating the climate. Less photographer than historian, he taught more

by prodding than example, but he stimulated the students' awareness of new currents in photography. When Siegel invited Garry Winogrand to be a visiting artist in 1972, the energy and simplified dogma of the new mentor overwhelmed most of the students. Like Siskind and Callahan before him, Winogrand espoused work instead of theory and took his students into the streets for their exercises with the camera. The descriptive 35-mm. aesthetic stimulated a countless number of thesis projects in the mid-seventies. The Winogrand stimulus overwhelmingly tied into the documentary tradition so firmly rooted in the program's history.

After Winogrand's one-year stay, no other forceful personality arrived to threaten the Siegel autocracy. In failing to find a replacement for Winogrand, Siegel unwittingly abetted the administration in its designs to deëmphasize photography. The department could no longer claim a modern graduate program competitive with other important programs around the country, and thereafter its importance diminished. The photography department had always depended on a charismatic mentor, and no one ever replaced the likes of Moholy, Siskind, Callahan, Siegel, and Winogrand.

The culminating element of student study—the thesis—was perhaps the I.D.'s most enduring contribution to the development of modern photography. As an experiment in picture making, the thesis attempted to stimulate the student to discover what could be said with the medium, not to seek absolute answers. As an educational concept, it integrated Moholy's teachings with the intentions of the new self-confident artist-photographer in the Siskind-Callahan mode. One guiding principle that all important contemporary I.D.-trained photographers have in common is the need to develop an idea into a mature statement as a body of work.

The best art requires a lifetime spent in its pursuit. Both Callahan and Siskind had this kind of devotion. Siegel underscored their example by drawing the students' attention to the importance of Siskind and Callahan and to the necessity of hard work. The best students were those who tried to emulate their teachers. They recognized that the contemporary photographer-artist could no longer work as if only subject matter determined the medium. The importance of the single documented object was simply a hangover from print journalism. The student learned that one picture begets another and so on, and he learned to realize that a given image made in exactly the way it had to be would look

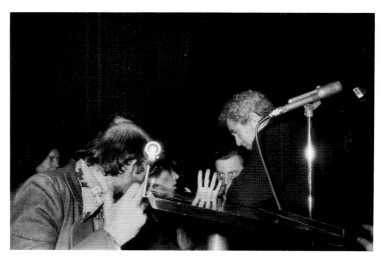

Garry Winogrand, *Norman Mailer's Fiftieth Birthday Party,* 1973

different from the one previously made. Of prime importance was the development of a unique personal style. Joseph Jachna sums it up:

—The I.D. has certainly inseminated us with some specific ideas, but I find that characteristic to be one of its most durable qualities, especially the attitude that an idea should be put to work. There is a value in knowing that a single picture, like a single gold nugget in a stream, is rare, and that there is more to find if the idea is pursued. Maybe all we need look for is a starting point; once we have that we know what to do.

Keith Smith, *Night Creature* (photo etching), 1972

Henry Holmes Smith, *Royal Pair, Neutral Variation*, 1951—79, and *Royal Pair, Golden Filament Variation*, 1951—76

"There is no more surprising, yet, in its naturalness and organic sequence, simpler form than the photographic series. This is the logical culmination of photography. Here the separate picture loses its identity as such and becomes a detail of assembly. In this concatenation of its separate but inseparable parts a photographic series inspired by a definite purpose can become at once the most potent weapon and the tenderest lyric.

László Moholy-Nagy, 1932

Joan Redmond, *Boathouse*, 1977

Charles Swedlund, *Untitled*, 1977

Arthur Siegel, *In Search of Myself*, 1951

Most people imagine that the mere existence of color photography means a great advance for photography as a whole. To be sure, it is a step forward in technique, but not in photography. . . . The time is approaching when the color photographer should apply the same practical and theoretical principles which the good modern black and white photographer . . . naturally accepts as a standard. László Moholy-Nagy, 1939

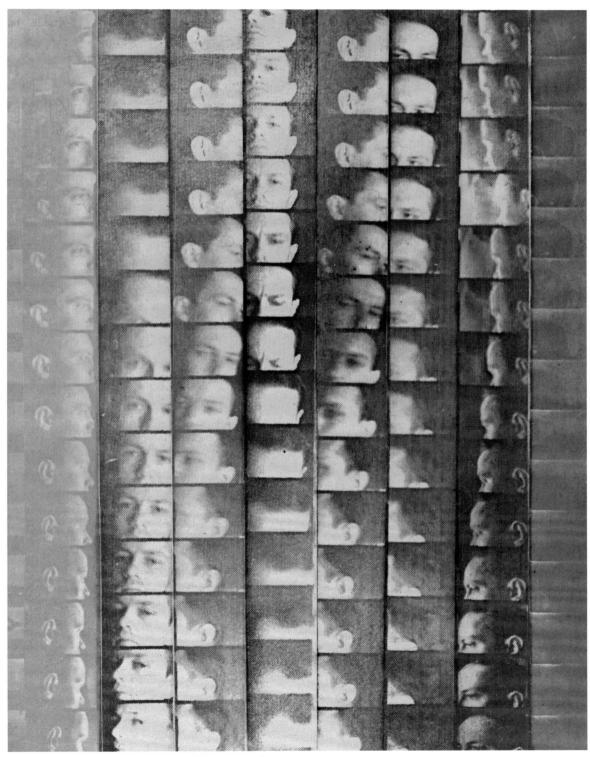

Keith Smith, *Head Movements* (photo etching), 1966

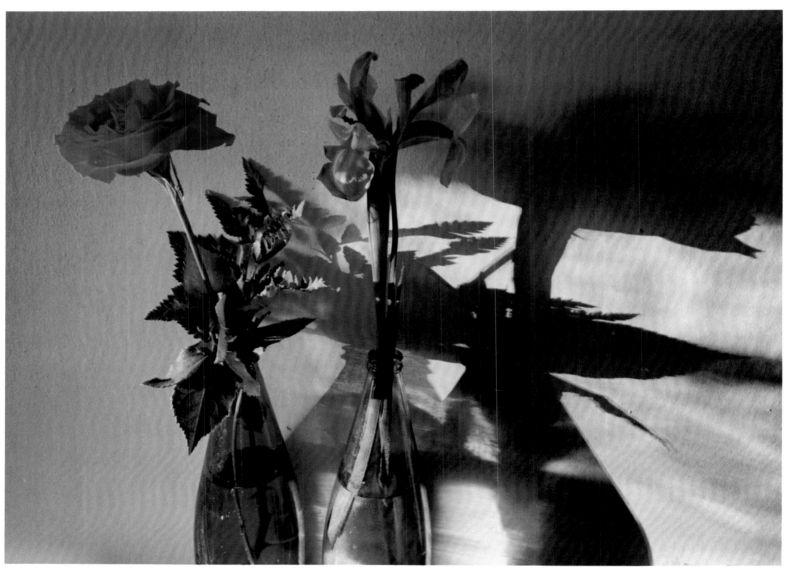

Douglas Baz, *Rose and Iris*, 1979

Patricia Carroll, from the series *Bitter Slice*, 1980

The true significance of the film will only appear in a much later, a less confused and groping age than ours. The prerequisite for this revelation is, of course, the realization that a knowledge of photography is just as important as that of the alphabet. The illiterates of the future will be ignorant of the use of camera and pen alike.

László Moholy-Nagy, 1932

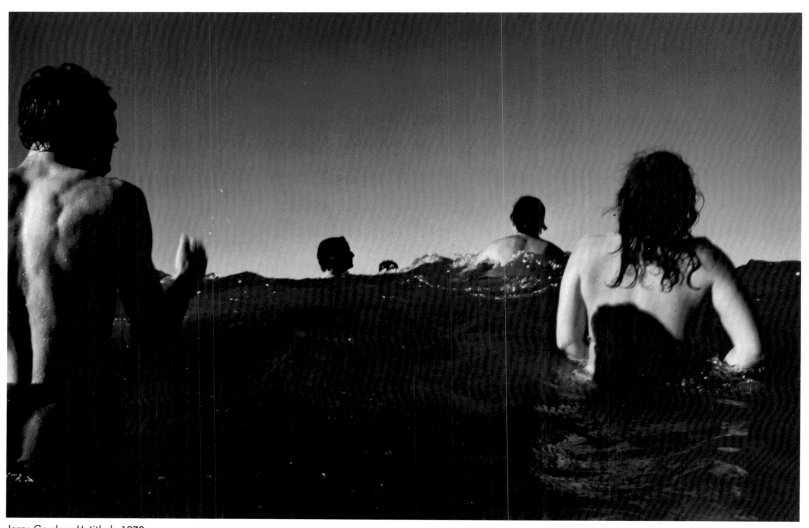

Jerry Gordon, *Untitled*, 1978

This chronology was prepared by John Grimes from school records and from interviews with teachers and individuals associated with the school. Ray Pearson's personal records supplied much otherwise unavailable information for the period 1937–55.

1923–28 László Moholy-Nagy teaches at the Bauhaus in Weimar (1923–25) and in Dessau (1925–28).

1937 *Summer*. On the recommendation of Walter Gropius, Moholy is offered the position of director for a school to be established in Chicago on Bauhaus principles. The school is sponsored by the Association of Arts and Industries. Moholy accepts the offer and names the school The New Bauhaus. *September 18*. School opens in Chicago at 1905 South Prairie Avenue. Original class of 33 students includes Nathan Lerner and Arthur Siegel (second term only), who later teach photography at the school. Photography, never officially taught at the Bauhaus, included as an essential part of the curriculum within the Light Workshop. Original faculty includes: L. Moholy-Nagy, director and head of the Basic Workshop; Gyorgy Kepes, head of the Light Workshop; Alexander Archipenko, head of the Sculpture Workshop; Han Bredendieck, Basic Workshop; Henry Holmes Smith, assistant to Kepes in photography and lab manager; David Duskin, Music; Carl Eckart, Physics; Charles Morris, Philosophy; Ralph Girard, Biology.

1938 *April*. Lacking support from founding organization, school closes.

1939 *February 19*. Moholy's school reopens as Chicago School of Design, 247 East Ontario Street (46 students). Kepes remains head of the Light Workshop, assisted by student Lerner. Smith no longer associated with school. *Summer*. Summer sessions begin in a country home in Somonauk, Illinois, provided by Walter and Elizabeth Paepcke. Sessions also held summers 1941–43. *Fall*. Frank Levstik hired to teach photography. Lerner hired to teach photography. Leonard Nederkorn teaches fall and spring terms part-time.

1940 *How to Make a Photogram*, traveling exhibit of photographs by students and faculty, organized by The Museum of Modern Art. *Fall*. James Brown teaches evenings, fall 1940–fall 1946.

1941 *Spring*. First class of full four-year program graduates; 5 students including Lerner and Milton Halberstadt. Kepes leaves end of summer term. *Fall*. Lerner becomes head of photography. Frank Sokolik hired.

1942 Edward Rinker teaches part-time evenings, fall 1942–summer 1945. Lerner teaches Basic Workshop and Product Design.

1944 School changes name to Institute of Design and gains college accreditation. Board of industrialists is formed by Walter Paepcke to oversee school operations.

1945 *Fall*. School moves to 1009 North State Street, at the corner of Rush.

1945–46 Returning World War II veterans increase student population from about 30 to over 350. Faculty increases from 10 to over 20.

1946 *Spring*. Siegel hired to teach photography and organize a summer workshop in photography. *Summer*. Photography workshop held. Teachers participating are Berenice Abbott, Erwin Blumenfeld, L. Moholy-Nagy, Beaumont Newhall, Frank Scherschel, Paul Strand, Roy Stryker, and Weegee. *Fall*. I.D. moves to 632 North Dearborn Street (formerly Chicago Historical Society). Siegel becomes head of photography section. Harry Callahan begins teaching. November 18, Moholy dies. Lerner named acting director.

1947 *Spring*. Serge Chermayeff named director, assumes duties fall. Posthumous publication of *Vision in Motion*, by László Moholy-Nagy (Sibyl Moholy-Nagy, editor), which explains Moholy's philosophy of education and includes examples from the work of students and faculty.

1948 *Spring*. Hillar Maskar hired as laboratory technician, teaches part-time through spring 1952. Buckminster Fuller teaches Shelter Design (also fall 1948). Ferenc Berko teaches (also fall 1948). *Fall*. Sokolik leaves at end of term. Victor Corrado teaches photography part-time evenings. Wayne Miller teaches (also spring 1949). Aaron Siskind visits I.D. at the suggestion of Todd Webb and meets Callahan and Siegel.

1949 *Spring*. Levstik resigns at end of term. Siegel resigns at end of term. Arthur Sinsabaugh teaches as student assistant. *Fall*. Callahan becomes head of photography. Sinsabaugh hired full-time. Konrad Wachsmann hired (Shelter Design) through spring 1955. Institute of Design becomes part of Illinois Institute of Technology. Henry Heald, president of Illinois Institute of Technology, is instrumental in attracting the school.

1950 *Spring*. Gordon Koster teaches part-time. *Fall*. Graduate program in photography instituted.

1950s Callahan and Siskind are principal photography teachers during this period, but are often assisted by visitors, evening teachers, and graduate students (e.g., George Nan, who taught color for several semesters in late 1950s).

1951 *Spring*. Keld Helmer Petersen teaches photography part-time. Chermayeff resigns. Crombie Taylor (Shelter Design) becomes acting director. *Summer*. Callahan, Siskind, and Siegel teach at Black Mountain College, North Carolina. *Fall*. Siskind begins teaching. Siegel teaches evenings in film program, sporadically through 1954. Dropping enrollment in the day program forces Sinsabaugh into the evening program, which he heads through 1957. *Spring*. Lyle Mayer teaches evenings periodically through late 1960s.

1955 *Spring*. Lerner leaves at end of term. *Fall*. Jay Doblin named director.

1956 *Fall*. School moves to present location, Crown Hall, Illinois Institute of Technology, 3360 South State Street.

1957 *Spring*. Sinsabaugh leaves. *Fall 1957 – Spring 1958* Frederick Sommer teaches with Siskind while Callahan takes leave of absence.

1958 Koster teaches one term part-time.

1961 *Aperture* publishes an issue devoted to the graduate photography program at I.D. I.D. Press publishes first book, *The Multiple Image, Photographs by Harry Callahan*. *Spring*. Callahan leaves at end of term for Rhode Island School of Design. *Fall*. Joseph Jachna begins teaching. Siskind becomes head of photography.

1963 *Spring*. Sommer returns to teach workshop in conjunction with show of his photographs. Siegel teaches part-time (also spring 1964). Students work on his book, *Chicago's Famous Buildings*, published by the University of Chicago Press, 1965. *Fall*. Reginald Heron teaches evenings (also fall 1965, spring 1966).

1964 Doblin leaves for two years. Lute Wassman is director in his absence.

1966 *Fall*. Bill Marten hired. Joe Sterling teaches basic photography through spring 1968. Siegel returns to teach part-time. Doblin returns as director.

1967 *Spring*. Wynn Bullock teaches one term. *Fall*. Siegel hired to teach full-time. *Summer*. Bauhaus show at I.D.; catalogue published.

1968 *Spring*. Doblin resigns. James Montague named acting director.

1969 *Spring*. Jachna leaves at end of term for University of Illinois, Chicago Circle. *Fall*. Charles Swedlund hired. Ken Biasco hired.

1970 *Spring*. Siskind retired by school at end of term.

1970s Part-time faculty (most for one term only) during the 1970s include Jonas Dovydenas, Jachna, David R. Phillips, Alex Sweetman.

1971 *Spring*. Siskind returns to teach one class. Swedlund leaves at end of term for Southern Illinois University. Siegel becomes head of photography program. *Fall*. Garry Winogrand teaches (also spring 1972).

1972 *Fall*. Alan Cohen hired.

1973 *Spring*. Ralph Fertig hired. Marten leaves at end of term. *Fall*. Benjamin de Brie Taylor appointed director.

1974 *Spring*. Arthur LaZar teaches one term. Cohen leaves at end of term. *Fall*. John Grimes hired.

1975 *Spring*. B. de Brie Taylor resigns. Fertig leaves at end of term.

1976 *Spring*. Dietmar R. Winkler named director. David Rathbun begins teaching.

1977 Winkler resigns in January. *Spring*. Biasco leaves to teach in Texas. *Fall*. To present, Patricia Carroll teaches.

1978 *February 1*, Siegel dies. *Spring*. Doblin returns as director for term. *Fall*. Grimes named acting director and head of photography. To present David Plowden teaches.

1980 *Fall*. Dale Fahnstrom (Product Design) named director.

1981 Rathbun resigns.

1959 Ray K. Metzker

1960 Kenneth Josephson

1961 Vernon Cheek, Robert Hilvers, Joseph D. Jachna, George Nan, Charles Swedlund

1962 Joseph Sterling

1965 Beverly Capps, Joanne Marten

1966 Barbara Crane, Reginald Heron, Roger Malloch, Thomas Porett, George Strimbu

1967 Thomas Barrow, Donald Bulucos, Kurt Heyl*, Thomas Knudtson, William Larson, Ronald Mesaros, John Seaholm, Arthur Sinsabaugh, Judith Steinhauser, Karen Titel, Jack Wilgus

1968 Roslyn Banish, Barbara Blondeau, James Erwin, Brian Katz, Lyle Mayer, Ronald Nameth*, Carla Romeike, Roland Sinclair, Keith A. Smith, Peter Van Dyke, Geoffrey Winningham

1969 Jerry Aronson, Kenneth Biasco, Thomas Brown, Linda Connor, Edgar Dewell, Jr., Robert Frerck*, Thomas Hocker, Charles Lyman, Hans Schaal*, Thung-Hong Sung, Ronald Taylor, Danae Voutiritsas

1970 Christopher Ayres, Wayne Boyer*, Constance Brenner, Richard Burd, Barry Burlison, John Church, Eileen Cowin, Joe Crumley, Marcia Daehn, Catherine Dawes, Antonio Fernandez, Ralph Fertig, Robert Florian, Patricia Jones, Nicolas Kolias*, Bernard Krule, Elaine O'Neil, James Raymo, Judith Ross, Robert Stiegler, Tedwilliam Theodore, Karin Vanek

1971 Calvin Kowal, Mark Ktastof, Roger Lundy*, Gerald Moeller*, Esther Parada, Joan Redmond, Lynn Sloan, J. Frederick Sway, Stuart Thomas, Warren Wheeler

After 1971 Cinema became separate from Still Photography.

1972 Douglas Baz, Patricia Carroll, Alan Cohen, Francois Deschamps, Alan Eastman, Douglas Harrison, William Maguire, Mati Maldre, Robert Mosher, William Murchison, Dale Quarterman, Ronald Rabin*, Charles Traub

1973 Michael Cinelli*, Andrew Eskind, James Newberry, Jr., William Wilson, Jr.*

1974 David Avison, Peter Chechopoulos*, Gary Cummens, Luise Graff, John Grimes, Lewis Kostiner, Donald Krejci,

Ronald Lichterman*, Euell Lindsey*, Michael Lutch, Peter McGrath, Ronald Skow*, John Sloan, Jr.

1975 Jonte Gerlach, Mary Lloyd, Joseph O'Hearn*, Timothy White

1976 Arthur Dahl, Roger Freeman, Jerome Gordon, Everett Greer*, Steven Meyers, Hershel Womack, Jr.

1977 Michael Abramson, John Alderson, Michael Burke, Hormoz Haghighi*, Douglas Severson, Adam Zipkin

1978 Kathleen Culbert-Aguilar, Mary Ernst, Sandra Greenberg*, William Iverson*, Elena Sheehan, Eileen Smith, Charlotte Trolinger

1979 Michael Anisfeld

1980 Robert Drea, Kenneth Joseph, James Paster*, Jay Wolke

1981 Donald DuBroff, Abdulkadir Topcuoglu

SELECTED BIBLIOGRAPHY

Avison, David. In *Panoramic Photography* by Diana Edkins. New York: Gray Gallery, New York University, 1977.

Callahan, Harry. *The Multiple Image*. Chicago: The Press of the Institute of Design, 1961.

————. *Harry Callahan Color*. Providence: Matrix, 1980.

————. *Water's Edge*. Old Lyme, Connecticut: Callaway Editions, 1980.

Carroll, Patricia. "Portfolio: Patty Carroll." *American Photographer* (December, 1980).

Connor, Linda. *Solos*. Millerton, New York: Apeiron Workshops, Inc., 1979.

Estrin, Mary Lloyd. *To the Manor Born*. Boston: New York Graphic Society, 1979.

Grimes, John. "Arthur Siegel: A Short Critical Biography." *Exposure*, 17, no. 2 (Summer 1979): 22–35. Chicago: Society for Photographic Education, 1979.

Haus, Andreas. *Moholy-Nagy: photographies, photogrammes*. Munich: Schirmer, Mosel, 1978.

Herzogenrath, Wulf, Tilman Osterwold, and Hannah Weitemeier. *László Moholy-Nagy*. Stuttgart: Gerd Hatje, 1974.

Ishimoto, Yasuhiro. *Chicago: Chicago*. Tokyo: Biyutsu Shuppan-sha, 1969.

Jachna, Joseph D. *Light Touching Silver*. Chicago: Chicago Center for Contemporary Photography, Columbia College, 1980.

Larson, William. *Fireflies*. Philadelphia: Gravity Press, 1976.

————. *Big Pictures: Little Pictures*. Philadelphia: Gravity Press, 1980.

Lebe, David, ed. *1938–1974: Barbara Blondeau*. Rochester, New York: Visual Studies Workshop, 1976.

Lerner, Nathan. *A Photographic Retrospective, 1932–1979*. Boston: Institute of Contemporary Art, 1979.

————. *Chicago: The New Bauhaus. Photographs 1935–1945*. Chicago: Allen Frumkin Gallery, 1976.

Lyons, Nathan, ed. *Contemporary Photographers*. New York: Horizon Press, 1967. Includes photographs by John Wood and Ray K. Metzker.

Metzker, Ray K. *Sand Creatures*. Millerton, New York: Aperture, Inc., 1979.

Moholy-Nagy, Sibyl. *Moholy-Nagy: Experiment in Totality*. Introduction by Walter Gropius. New York: Harper and Row, 1950.

Moholy-Nagy, László. *Painting, Photography, Film*. Trans. by Janet Seligman. Cambridge, Massachusetts: MIT Press, 1969.

————. *The New Vision: From Material to Architecture*. New York: Brewer, Warren and Putnam, 1930.

————. *New Vision: Fundamentals of Design, Painting, Sculpture, Architecture*. New Bauhaus Books, no. 1. Trans. by Daphne M. Hoffman. New York: W.W. Norton, 1938.

————. *Vision in Motion*. Institute of Design I. D. Book, no. 2. Chicago: Theobald, 1947.

Photographs: 1948–1980. Barbara Crane. Tucson: Center For Creative Photography, University of Arizona, 1981.

Photographer and the City. Chicago: Museum of Contemporary Art, 1977.

Rice, Leland, and Steadman, David W., eds. *Photographs of Moholy-Nagy: From the Collection of William G. Larson*. Claremont, California: The Galleries of the Claremont Colleges, Pomona College, and Scripps College, 1975.

Roh, Franz, ed. *Moholy-Nagy, 60 Fotos*, vol. 1. Berlin: Fototek, 1930.

Sinsabaugh, Art. *6 Mid-American Chants by Sherwood Anderson/11 Midwest Photographs by Art Sinsabaugh*. Highlands, North Carolina: The Nantahala Foundation, Jonathan Williams, 1964.

Siskind, Aaron. *Photographs*. New York: Horizon Press, 1959.

————. *Places*. New York: Light Gallery/Farrar Straus & Giroux, 1978.

————. *Harlem Document*. Providence: Matrix, 1981.

Smith, Keith A. Interview in *Photography Between Covers*, ed. by Thomas Dugan. Rochester: Light Impressions, 1980.

Szarkowski, John, ed. *Callahan*. Millerton, New York: Aperture, Inc. in association with The Museum of Modern Art, 1976.

————. *Mirrors and Windows: American Photography since 1960*. New York: The Museum of Modern Art, 1978. Includes photographs by Linda Connor, Kenneth Josephson, Ray K. Metzker, Arthur Sinsabaugh, Keith A. Smith, Geoff Winningham, Garry Winogrand.

Traub, Charles. *Beach*. New York: Horizon Press. 1978.

Tucker, Jean S. *Light Abstractions*. St. Louis: University of Missouri Press. 1981. Includes photographs by László Moholy-Nagy and Nathan Lerner.

White, Minor, ed. *Aperture 9*, no. 25 (1961). Entire issue devoted to Institute of Design.

Wingler, Hans M. *The Bauhaus*. Cambridge, Massachusetts: MIT Press, 1969, repr. 1978.

————. *Neue Bauhausbucher: Malerei, Fotografie, Film*, no. 8. Mainz and Berlin, Germany: Kuperberg, 1967.

Winogrand, Garry. *Stock Photographs: The Fort Worth Fat Stock Show and Rodeo*. Austin: University of Texas Press, 1980.

————. *The Animals*. New York: The Museum of Modern Art, 1969.

————. *Women Are Beautiful*. Introduction by Helen Gary Bishop. New York: Light Gallery, 1975.

Winningham, Geoff. *Saturday Night at the Coliseum*. Houston: Allison Press, 1971.

————. *Going Texan*. Toronto: Herzig-Somerville Ltd., 1972.

COPYRIGHT

Copyright © 1982 Aperture, Inc. Library of Congress Card Catalogue No. 80-68713. Clothbound ISBN 0-89381-067-3. Staff for *New Vision*: Editor/Publisher, Michael E. Hoffman; Associate Editor, Carole Kismaric; Managing Editor, Lauren Shakely; Production Manager, Stevan A. Baron; Editorial Coordinator, Ramiro A. Fernandez.

Design: Marvin Israel; Design Associate, Anne Todd.

All rights reserved under International and Pan-American Copyright Conventions. Published by Aperture, Inc. Distributed in the United Kingdom, Commonwealth, and other world markets by Phaidon Press Limited, Oxford; in Canada by Van Nostrand Reinhold, Ltd., Ontario; and in Italy by Idea Books, Milan.

Aperture, Inc., publishes a periodical, portfolios, and books to communicate with serious photographers and creative people everywhere. A complete catalogue will be mailed upon request. Address: Millerton, New York 12546. Manufactured in the United States of America. Composition by David E. Seham, Inc., Metuchen, New Jersey. Printed by Halliday Lithograph, West Hanover, Massachusetts. Color separations by Pro Color, Inc., Danbury, Connecticut. Color pages printed by D. L. Terwilliger, Inc., New York. Bound by Sendor Bindery, New York.

The exhibition *The New Vision: Forty Years of Photography at the Institute of Design* originated at Light Gallery, New York, in 1980, and Aperture gratefully acknowledges the cooperation of Light—especially the editorial and administrative assistance of David Brown, Assistant to the Director—in the preparation of this publication. The project could not have been completed without the generous participation of the faculty and former students of the Institute of Design. Aperture also thanks Andy Grundberg, who provided valuable research for this publication.

PHOTO SOURCES

Michael Abramson, 53; American Brands, Inc., 17 (top); David Avison, 40 (below); Douglas Baz, 70; Bettmann Archive, Inc., 16 (above), 17 (Trylon), 17 (Chicago); Patricia Carroll, 71; Chicago Historical Society, 18 (Daley); Linda Connor, 42 (above); Eileen Cowin, 62 (right); Barbara Crane, 49; Edwynn Houk Gallery, Chicago, 29, 35; Estate of Arthur Siegel, courtesy Edwynn Houk Gallery, 22, 31, 68; Mary Lloyd Estrin, 62 (left); Gestetner Corporation, 16 (left); Jerry Gordon, 72; Indiana University Art Museum: Art Sinsabaugh Archive, 40 (above), Henry Holmes Smith Archive, © 1976–1979 Henry Holmes Smith, 65; Institute of Design Archive, Illinois Institute of Technology, 15 (above, four photos); Joseph D. Jachna, 38, 56; William Larson, 41; Light Gallery, New York, 2–3, 15 (van der Rohe, photogram), 18 (Siegel and Moholy-Nagy, Siskind), 21 (Siegel and Callahan, Lerner, Winogrand inset), 24, 25, 26, 27, 32, 33, 42 (below), 43, 45, 50, 63; Moholy-Nagy/*New Vision*, courtesy Wittenborn Art Books, 30; Moholy-Nagy/*Vision in Motion*, courtesy Paul Theobald & Co., 12 (Moholy-Nagy); Lucia Moholy, 6; Neuman, ed./*Bauhaus and Bauhaus People* © Van Nostrand Reinhold Company, repr. by permission of the publisher, 12 (Itten); New York Public Library Picture Collection, 13 (Bauhaus building), 16 (below), 17 (taxi); The Richard Nickel Committee: The Art Institute of Chicago, 48; Michael Oliver, 4; Professor Elmer R. Pearson collection, 9, 18 (Joyeux Noel); The Philadelphia Museum of Art, Purchased, Contemporary Photography Exhibition and Stieglitz Fund, 36; Prakapas Gallery, New York, 11; private collections, 8, 58, 69; Joan Redmond, 66; Collection of Mr. and Mrs. David Ruttenberg, 54; Joseph Sterling, 55; Charles Swedlund, 67; Charles Traub, 57; UPI, 13 (Gropius), 17 (Roosevelt); Visual Studies Workshop Collection, Rochester, New York, 41 (below), 47, 60, 61, 64; Wingler/*Bauhaus* © The MIT Press, 10, 12 (left column), 13 (title page, workshop, Bauhaus faculty), 15, Breuer, 18 (above left, below left); 21 (all illustrations except Siegel and Callahan, Lerner, Winogrand inset); Geoff Winningham, 53 (above); Young Hoffman Gallery, Chicago, 39, 44.